Christmas '08

Hope you enjoy
the beauty & simplicity
of this book ... a tree
found. Love,
Mom

Moods in the Landscape

A. E. Bye

Introduction by Reuben M. Rainey

S P A C E M A K E R P R E S S

Washington, DC

Cambridge, MA

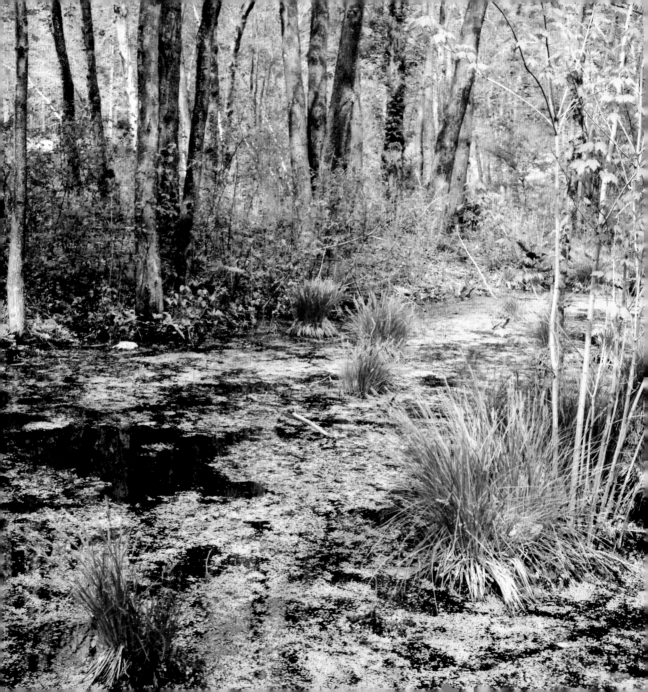

MOODS

IN THE

LANDSCAPE

A E BYE

Publisher: James G. Trulove
Art Director: Sarah Vance
Designer: Elizabeth R. Krason
Editor: Jane Gillette Brown
Printer: Palace Press
International

ISBN: 1-888931-18-3

Inquiries should be addressed to:
Spacemaker Press
147 Sherman Street
Cambridge, Ma 02140

Contents

Acknowledgments

This book could not have been completed without the aid of friends, relatives, professional colleagues, and associates of my landscape architecture office. My heartfelt thanks to Professor Reuben Rainey of the Department of Landscape Architecture at the School of Architecture at the University of Virginia, who wrote the introduction. To my friend and former associate, David H. Engel, who helped me, many years ago, to get started on this venture. To Janis Hall, my partner, whose creative and incisive mind steered me away from irrelevant ideas and concepts and toward more exciting ones. Lastly, I would like to thank my cousin Christiaan van Eeghen for his insight into the Dutch artists of the seventeenth century. Thanks also go to my associate Helen Dimos, who with fresh eyes revised captions and suggested changes. And to John Jay Iselin, president of the Cooper Union, who endorsed this book for publication.

To Janis Hall, my partner, whose poetic work

with shadows has been my inspiration.

To my cousins Christiaan

and Meke van Eeghen

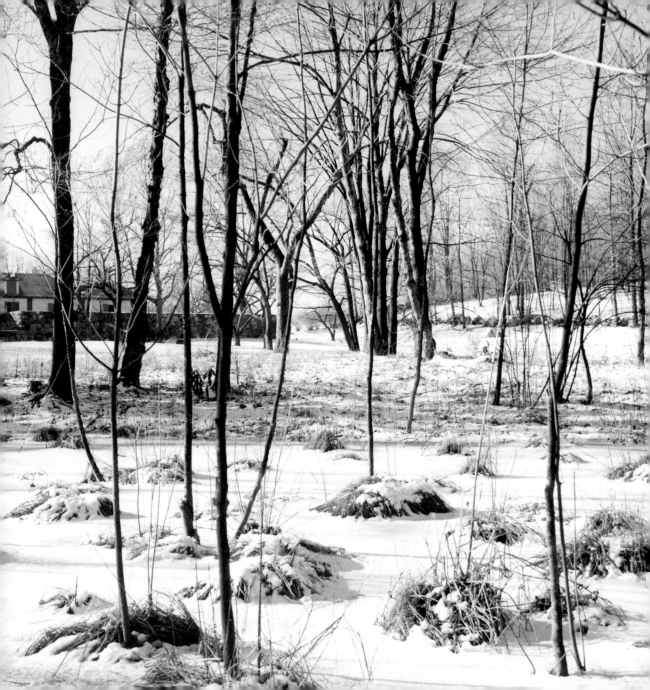

introduction

Introduction

9

Reuben M. Rainey

A. E. Bye's *Moods in the Landscape* is a second, more far-ranging odyssey into regions

briefly charted in his first book, *Art into Landscape, Landscape into Art*. In a work that is

part autobiography and part invitation, he reflects on the potential of landscapes to

engage our emotions and prompt reverie. As autobiography, it presents us with a

very personal photographic diary of a landscape architect's lifelong engagement

with landscapes of immense aesthetic, ecological, and geographical diversity. Bye's

acute and penetrating camera eye ranges from the New England coast to the

strands of the Netherlands Antilles, from the elegant serenity of Belgium's parks to

the mysterious penumbra of Georgia's swamps. Bye's primary interest is in the

"moods" such landscapes evoke, and by "mood" he means the pervading impression a landscape leaves on our feelings and emotions. This interest extends well back into his childhood when one of his favorite activities was to venture forth, with simple camera in hand, into the forest near his ancestral home in Bucks County, Pennsylvania, to experience and record its peace and serenity—qualities a shy and introverted child found strengthening and reassuring. Bye's brief and poetic captions also reveal his personal response to the various landscapes so sensitively recorded in his numerous photographs. These are for the most part natural landscapes, although a few cultural ones, such as agricultural land and urban parks,

are included. None of Bye's own design work appears, although the natural scenes

he records are the well-spring of the aesthetic embodied in his professional practice,

which focuses primarily on residential site planning. The meticulously close obser-

vation of natural landscapes attested to in Bye's photographs is the starting point for

his aesthetic of abstraction. Bye, in his design work, does not copy a region's natural

landscape; rather he abstracts it to create a series of landscape compositions that

accentuate the intrinsic qualities of the landscape and intensify our experience of it.

Mere copying could never achieve this. In addition to constituting a memorable

and engaging personal statement, these photographs and brief commentary

are also an invitation. Bye encourages us to compare our own responses

with his. His captions are not intended as canonical statements, but as

points of departure for our own dialogue with his photographic diary. Bye

is quite aware that "mood is subjective" and different individuals will vary

in their response to the same landscape. For those of us who are designers,

Bye's work issues a further invitation. We are gently urged to consider

"mood" as a significant unifying element in our own design work. Bye does

not theorize much about why certain elements in a particular landscape evoke

moods. We will not find in his reflections references to primordial landscape

memories encoded in our DNA, Jungian archetypes, theosophical theories of the

"harmonic vibrations" of objects, or other attempts to account for our emotional

reciprocity with various landscape elements. Bye is more pragmatic and empirical.

He places his photographs before us and encourages us to respond. He leaves it to

us to draw what theoretical conclusions may satisfy us. In his brief captions Bye

does from time to time imply certain interrelationships among form, light, and

mood. The darkness of a swamp, which conceals its objects and boundaries, tends to

produce feelings of "mystery." The muted tonality and gently undulating horizontal

surface of a meadow at dusk usually evoke "serenity." However, these are but brief

conjectures. Bye is opposed to all formulae. He is also cognizant that his photo-

graphs have frozen significant moments of what are very dynamic phenomena.

The same landscape can, on other occasions, depending on weather, season, and

time of day, evoke quite different moods. Bye is also well aware of how difficult it is

to express in words the rich and complex nuances of mood. Hence his own

descriptive terminology is flexible and tentative. Terms like "serene" and "mysterious"

are straightforward, but when Bye uses such categories as "dazzling" and "brittle,"

it may appear he is referring more to qualities of landscapes than to the moods

they evoke. Perhaps so, but Bye does not want us to quibble over semantics.

He wishes instead that we recognize the tentativeness and limitations of language

and chart our own feelings as we respond to his photographs. There is also the

issue of how viewing photographs differs from the actual experience of what they

depict. Obviously our encounter with the flatness, tonality, framing, and compo-

16 sitional strategy of a photograph, whether in color or black and white, will differ

from our experience of a three-dimensional landscape. Additionally a photograph,

in capturing an exclusively visual moment, precludes our immediate experience

of sound, smell, touch, and taste, which often are potent elements in evoking

mood. The fact that Bye has attempted to convey moods through his photo-

graphic diary presupposes that he believes such photographs, despite their visual

abstraction and bracketing of certain senses, can nevertheless resonate with our

emotions in a manner similar to our experience of actual landscapes. Also, it is

important to understand, as Jory Johnson has aptly pointed out in his essay in

Abstracting the Landscape: The Artistry of Landscape Architect A. E. Bye, published 17

in 1990 by Pennsylvania State University, that Bye's photographs are a "mechanical,

guileless chronicling" of natural and cultural landscapes. Bye is well aware of our need

for a full, sensual engagement with a landscape. Many of his captions are clearly

intended to supplement the visual imagery of his photographs with evocative

observations on the sounds and textures of a place. He speaks of the "rattle" of dead leaves that "noise the air," the "lapping" of water at a marsh's edge, the "swishing" of leaves in a strong wind. Bye does not consider his photographs to be works of "art," that are ends in themselves. He usually photographs at eye level with a 28-mm lens and avoids the special effects obtainable by the use of filters or ultra-wide-angle or telephoto lenses. He also avoids unusual or original compositions. His intention is to record a landscape as we would experience it by simply walking through it. Thus, as Johnson notes, "It is critical to an appreciation of Bye's work that viewers look through the photographs, not at the photographs."

Nothing would suit Bye better than to have his photographs act as a catalyst to move us into the world of living landscapes to experience them in all their sensual complexity and to observe the moods they might stir within us. The issue of mood, usually treated under the more general category of "landscape effects," was frequently discussed in the theoretical literature of eighteenth- and nineteenth-century landscape architecture by such authors as Edmund Burke, William Chambers, Frederick Law Olmsted, and a host of others. Two particular literary sources have nurtured Bye's intense interest in the subject: nineteenth-century American fiction and the landscape design text of his

student days at Pennsylvania State University. Bye is particularly fond of the

work of Washington Irving, especially his frequent descriptions of the moods

evoked by landscapes in such pieces as "The Stout Gentleman" and "The Legend

of Sleepy Hollow." Bye's student textbook was Henry Hubbard and Theordora

Kimball's *Introduction to the Study of Landscape Design*, the canonical treatise in

most American schools from 1917 to the Second World War. Bye so respected

this work from his student days that when he began teaching landscape archi-

tecture at Columbia University and Cooper Union some twenty years after he

began his practice he used major portions of it as a guide to structuring his

courses. The similarities between Bye's thoughts on mood and Hubbard and Kimball's are quite apparent. Both understand mood (or "landscape effect," as Hubbard and Kimball would call it) to be largely an "emotional" response to the "perception" of a particular landscape. Both regard mood as a crucial element in a design—one that provides both unity and interest. Both agree that individuals will vary in their responses to the same landscape so that there is no simple correlation between form and mood. Both utilize photographs to illustrate various moods. Both avoid the pathetic fallacy by recognizing that we have a tendency to project human feelings onto the landscape and regard them as if they were

intrinsic qualities of the landscape itself. For example, when we speak of such

things as a landscape's "joyfulness" or "melancholy" we employ figures of speech.

Both maintain that mood is evoked by direct sense experience as well as the

prior associations we may bring to a landscape. There are differences as well.

22 Bye is less inclined than Hubbard and Kimball to speculate in detail on the causes

of mood in landscape. Also he delineates a far wider range of moods than Hubbard

and Kimball and is more inclined to view mood as rising from contrasting

elements such as the soft texture of plants against the hardness of a rock outcrop-

ping or the brilliant luminosity of backlighted meadow grass juxtaposed with the

penumbra of the forest. The important issue of mood in landscape is infrequently

addressed in today's theory of landscape architecture. Bye's straightforward and

suggestive visual diary may serve to renew that inquiry. Discussion of the possibility

of an emotive dialogue with landscapes is hardly an invitation to self-indulgent,

Romantic sentimentality. It is a serious investigation of a significant human

sensibility. It may well be that in our attempts to address our daunting and

complex environmental problems on a worldwide scale the cultivation of this

sensibility will help infuse our efforts with the passion and commitment that will

insure our success and without which we will surely fail.

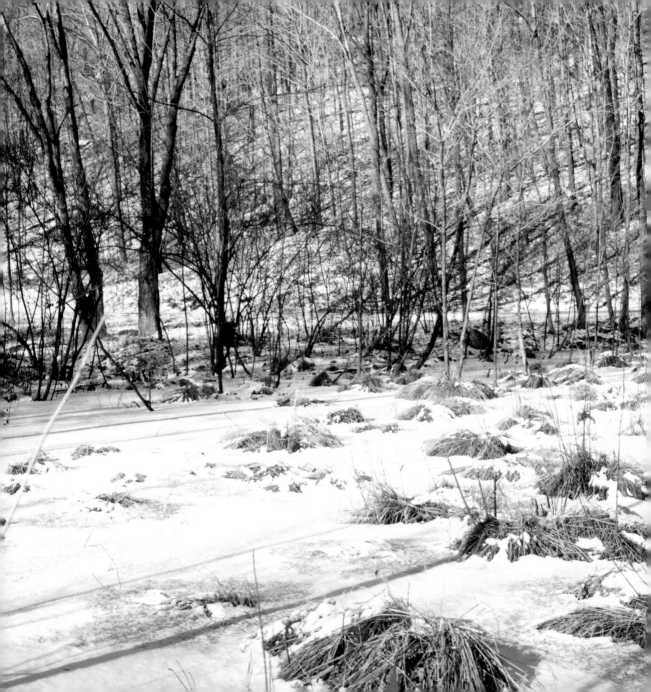

moods Moods in the Landscape 25

A. E. Bye

This book is a photographic essay on illusion and allusion in the landscape or, in brief,

moods. I have tried to capture and identify moods in landscape by studying color,

light, shadow, texture, movement by wind, weather conditions, and seasons, and the

individual characteristics of a particular environment. The photographs in this book

26 and their captions are intended as lessons in "seeing" landscapes and as challenges to

designers to design appropriately and, if possible, to incorporate mood into their land-

scape designs. If a certain environment has a strong central condition, a design could

be developed around the mood evoked by that condition. In essence mood could be

the unifying element of a design in much the same way that Dutch painters of the

seventeenth century developed their paintings around the essence of mood. Today, in

a country in which there is a lack of unity between the natural world and what we

build, mood could potentially become a unifying element of design. We often turn

to nature to satisfy emotional needs that we cannot satisfy through the environments

in which we live. Our native landscapes can provide us with feelings of serenity or

mystery or the feeling of the sublime, but rarely do we attempt to re-create these

moods in our designed landscapes. In less sophisticated cultures in which people

interact directly with nature for their survival we often find a more sensitive inte-

gration of human-made forms and the landscape, and from this we must take a cue.

We should look to the native condition for inspiration to design our own landscapes

and gardens with more poetry and emotion. There is a widespread belief that nature is

slipping away from us. Many people do look to the natural landscape of their region

for inspiration for their own landscape environment. The elements of nature are com-

plex and diverse, full of the contradictions that we also find in humanity. They

frequently become a metaphor for the human condition. Our gardens should reflect

this complexity. Many landscapes have a certain coherence because of a particular

mood. Too many people begin the design process by looking in garden books rather

than looking right at their local environment to draw inspiration for a design. This

book points out what wide and varied landscapes exist throughout the world and

how unique they are for their region. A landscape in the Midwest should not evoke

the same mood as one on the eastern seaboard. The particular regional landscape

should be addressed by the individual design process. The sun arcs through the sky, and

so a morning scene is different from an evening scene. And a winter scene is not a

summer scene. This is a great fascination—that the landscape is constantly changing

not only from the weather and seasons, but also from the sprouting seedlings pushing

up youthful growth. Some of the most visually provocative scenes in nature are to be

found in the harshest situations. I discovered an example of this along the Dutch coast,

near the city of Scheveningen, in a forest of old oaks that exemplified contortion in

plant growth. The trees had been growing in sand dunes for centuries and had been

twisted and dwarfed by the relentless winds blowing in from the North Sea. Contor-

tions of the branches also resulted from their natural attribute to twist and turn, found

30 in almost all species of oak, but in this case accentuated by their tenacious will to

survive in a brutal environment. There has been an attempt to illustrate a unifying

central theme for each picture. We all too frequently seek variety and diversity only to

find complexity, confusion, and disunity. Thus, each photograph conveys a definite

message of mood—illusion or allusion. Certainly we know that our past experiences

and associations can color our responses. Yet, since this book is subjective in nature,

it is my prerogative to say what I see, what I please, what I believe. It will be clear to

the reader that the common and the obvious have been eliminated.

shadows A few of the projects show the phenomena of shadows as an important design

component of the landscape. We know the desirability of a bright sun on a clear

day no matter what time of the year. But usually early morning or late afternoon

is when we see longer shadows streaking across an open lawn or meadow. In some

instances, when the open area has been sculpted, so to speak, with undulations,

the landscape is animated, and if the terrain has been molded with mounds and

valleys, the shadows will rise and fall (and, of course, move) to accentuate the

manipulations that have been made to the contours. It is usually necessary that

vertical elements be part of the design for the streaking to occur. They may be

32 trees of various heights (slender or not), fences, architectural elements, or any

slender object that can cast a long shadow. It is to be understood that the seasons

of the year will change the falling of the shadows. A summer scene will differ

from a winter one. But, no matter, we should enjoy the difference.

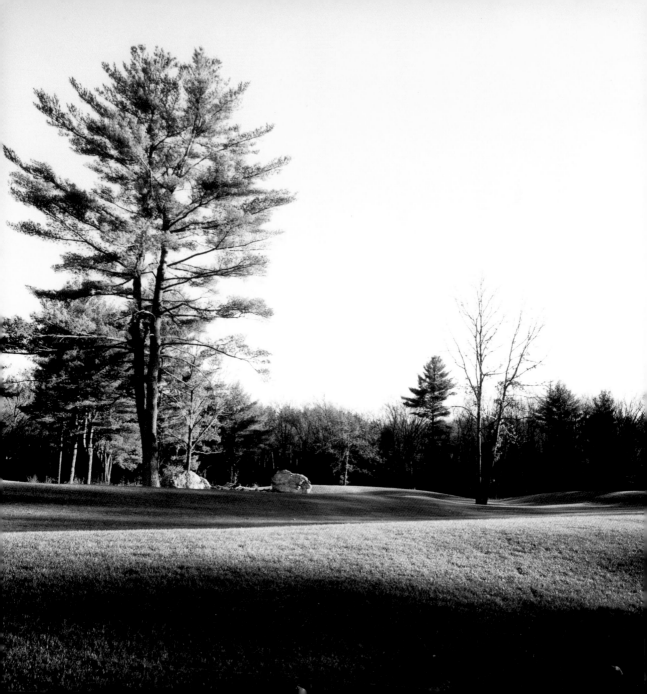

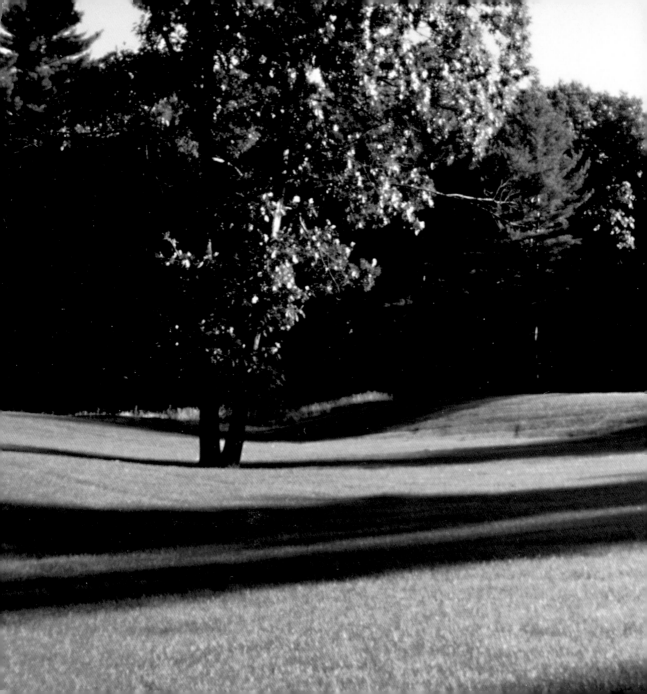

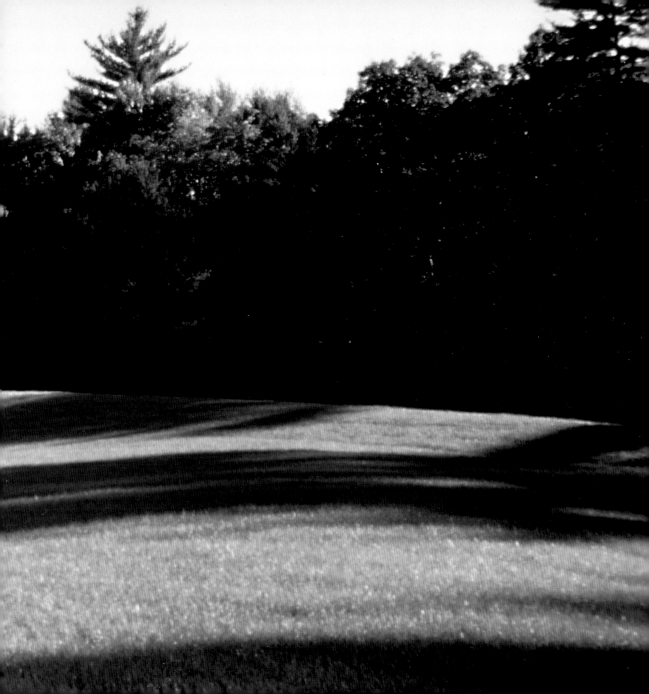

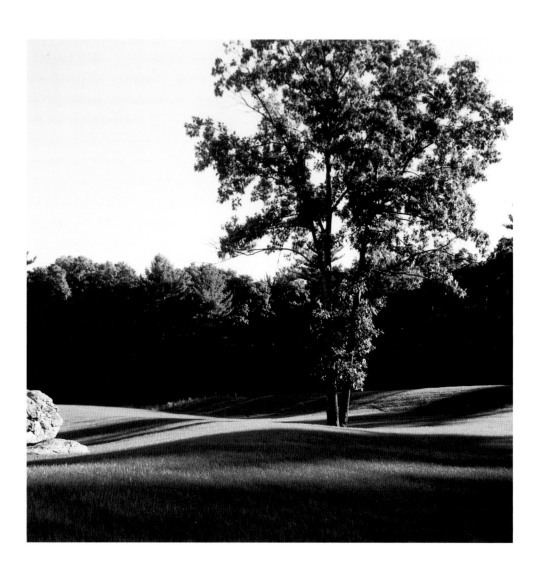

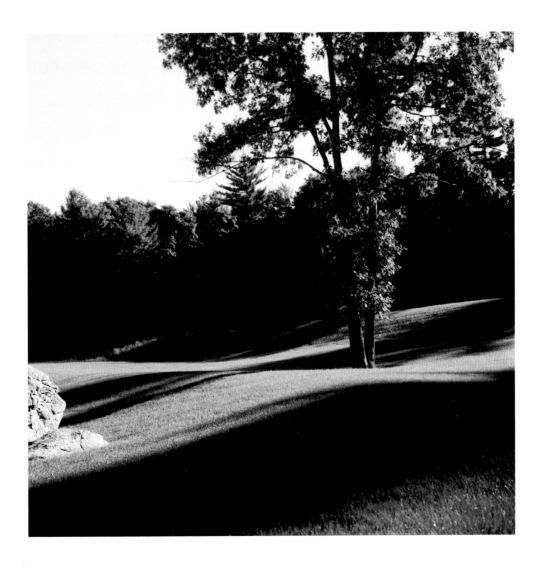

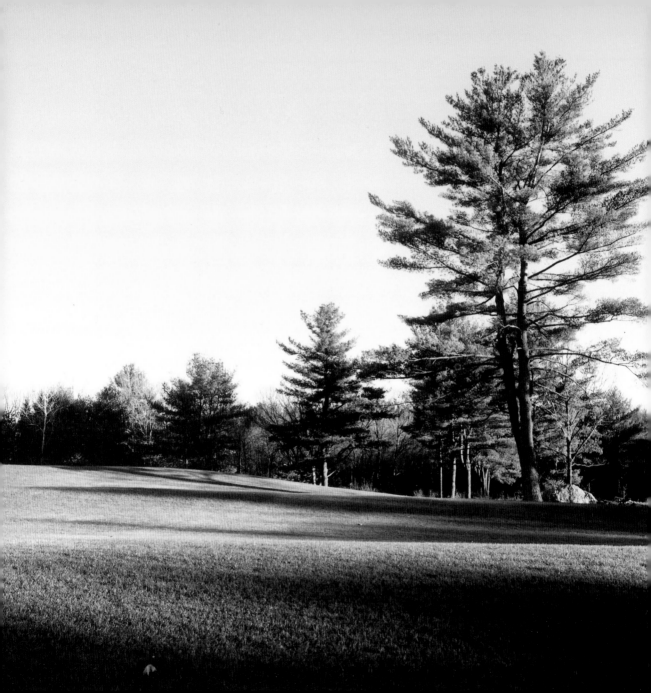

Acoustic	Elegant	Malevolent	
Assertive	Friendly	Melancholic	
Brittle	Grand	Mysterious	
Cold	Grotesque	Serene	Coda
Contorted	Humorous	Sheltering	
Dazzling	Lively	Suspended	
Delicate	Luminous	Tenacious	

in the landscape

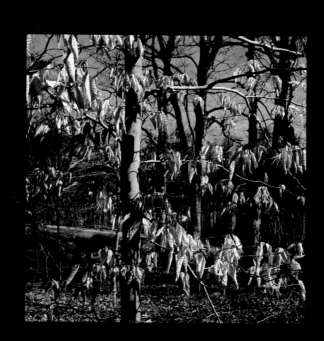

acoustic Acoustic

Oak Leaves

Pine Barrens

New Jersey

For certain species of oak, leaves remain on the twigs and branches throughout late fall and winter. When the wind blows, only slightly, they rattle and noise the air to delight our senses.

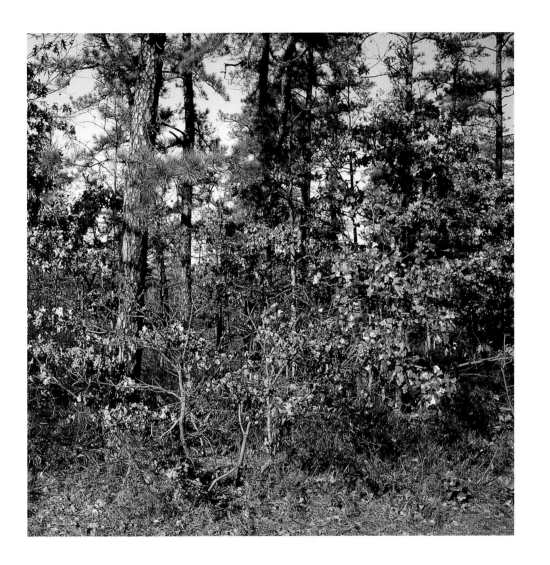

43

American Beech Leaves

Montgomery Pinetum

Cos Cob, Connecticut

44

The dry, crisp fallen leaves of autumn:

Have you looked at their patterns? Their colors?

Some remain upon the ground for years.

Others vanish with the wind.

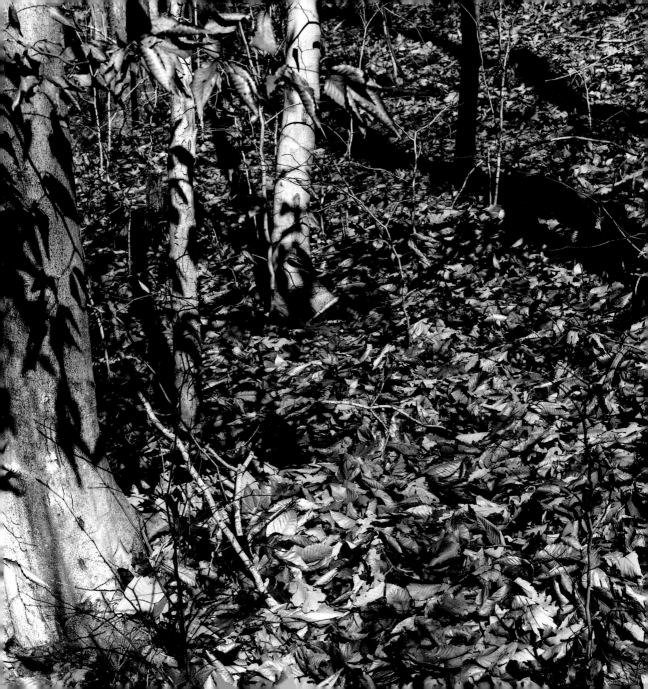

Marsh Grasses New Jersey Coast

A watery scene arouses our acoustical sense. We can hear the water lapping, the delicate rushes swishing in the unseen wind, and the occasional cries of water fowl.

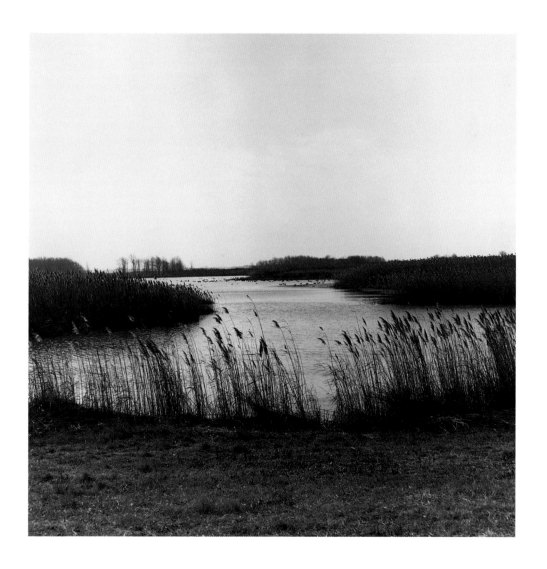

assertive Assertive

49

Casuarina Trees

Near Miami

Florida

A dramatic example of assertiveness. These casuarina *(Casuarina cunninghamiana)* trees are imposing themselves for an extended distance, almost to the point of monotony. Their planted distance from each other is the same for miles and miles. No other kind of tree is to be seen.

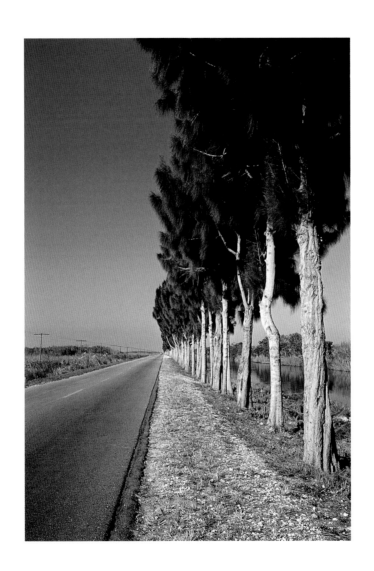

Red Cedars

Pound Ridge

New York

Red cedars *(Juniperus virginiana)* contribute substantially to the landscape character of the northeastern United States. Their irregular dark green narrow shafts punctuate the sky until they grow very old and lose their familiar form. Cedars can be used as background screens to offset lighter-colored plants, especially meadow grasses in late fall and winter landscapes.

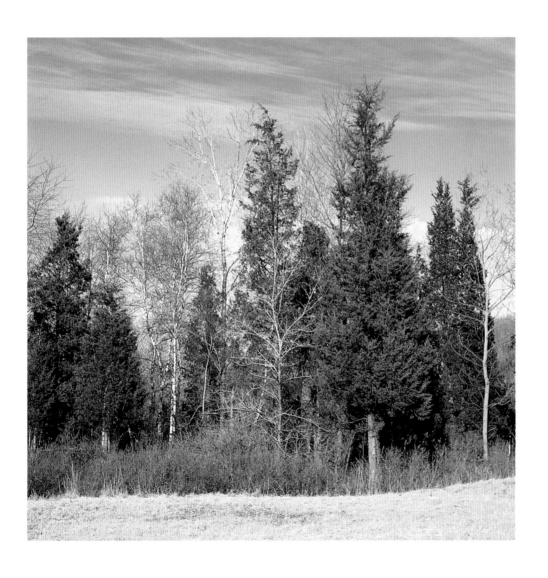

Church with Cypress Trees

Provence

France

This scene offers an extraordinary example of
how architecture can be united with nature
through the assertive form of trees. In this work
of a local genius, the verticals of the cypress
(Cupressus sempervirens) playfully repeat the forms
of the steeple of the church, creating a powerful,
uncompromising, and visually unifying effect.

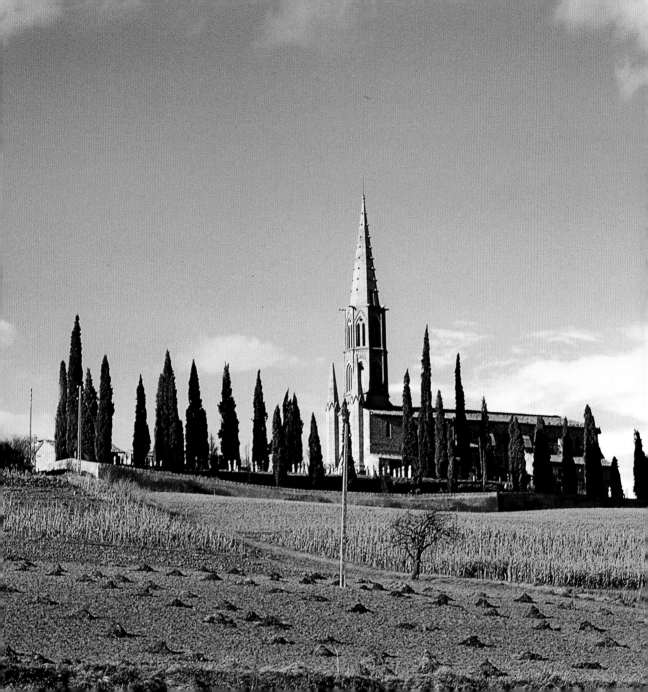

Scotch Pines The Netherlands

Pine foliage creates forceful abstract patterns

against the sky. Notice that the voids between the

branches of these Scotch pines *(Pinus sylvestris)*

play as important a role in the design as the

branches and foliage themselves.

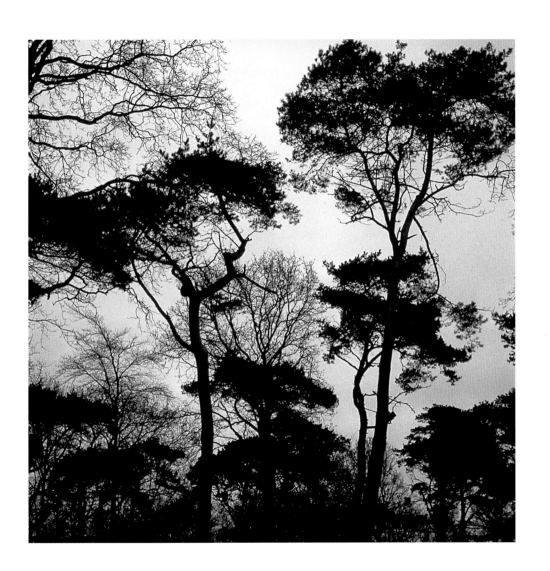

American Elms

Philadelphia

Pennsylvania

Two American elms *(Ulmus americana)* are seem-

ingly asserting themselves for space. The one on

the right is "attacking" the one on the left with

its gnarled, contorted branches. The tree on the

right "overpowered" the tree on the left and

today grows alone.

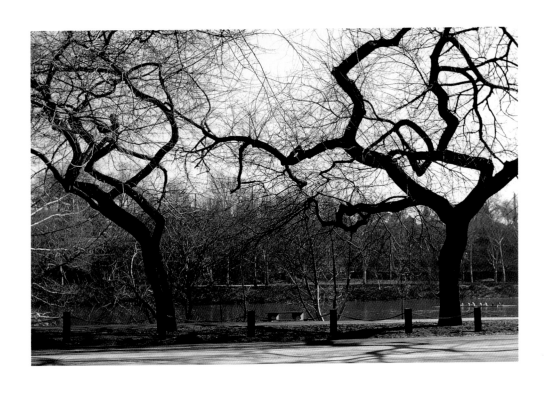

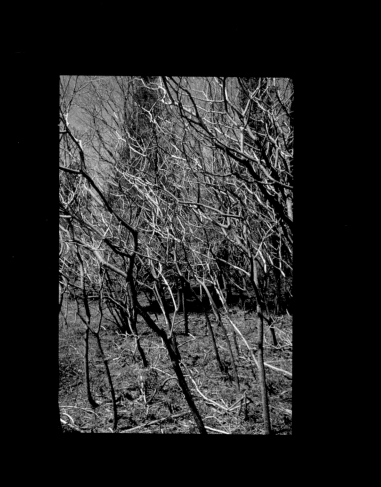

brittle
Brittle

61

Chestnut Oak

Ellenville

New York

On mountain tops where this chestnut oak

(Quercus prinus) is tortured from the assaults of

wind, rain, ice, and snow, its brittle, light gray,

fallen forms express the struggle.

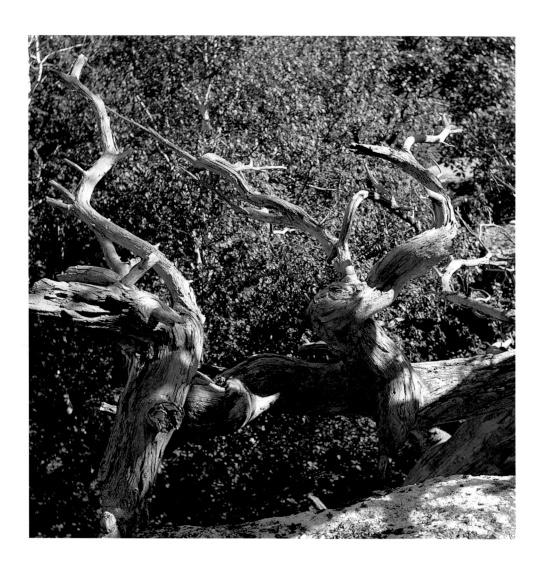

Fallen Spruce

Monhegan Island

Maine

We are fascinated by the fallen forms of trees, just

as we are fascinated by the skeletons of dinosaurs,

snakes, and birds.

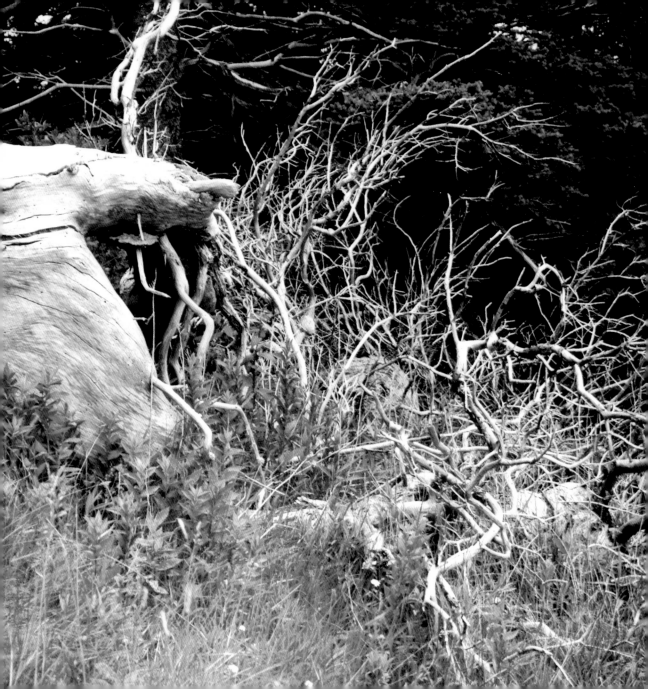

White Pine

Falmouth

Cape Cod, Massachusetts

Every stage of a tree's development is interesting.

In this white pine *(Pinus strobus)* the dead branches

remain. To cut these away considerably dimin-

ishes the tree's visual impact and its importance

in a landscape scene.

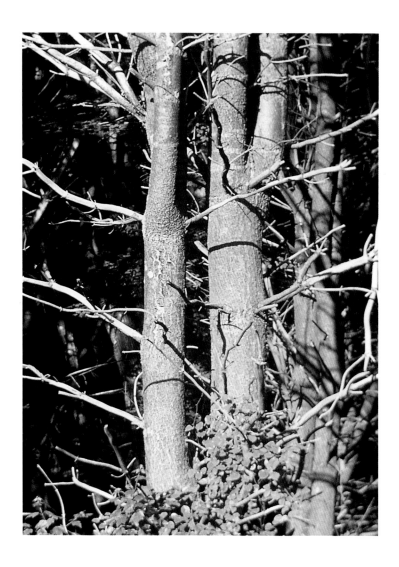

Spruces and Firs

Port Clyde

Maine

In any forest a certain percentage of vegetation is dead or decaying and dying. But in their disintegration they visually enhance the scene by their light gray and light brown forms. In this composition, black spruce *(Picea mariana)* and balsam fir *(Abies balsamea)* gain importance against the dark mystery of the forest in the background.

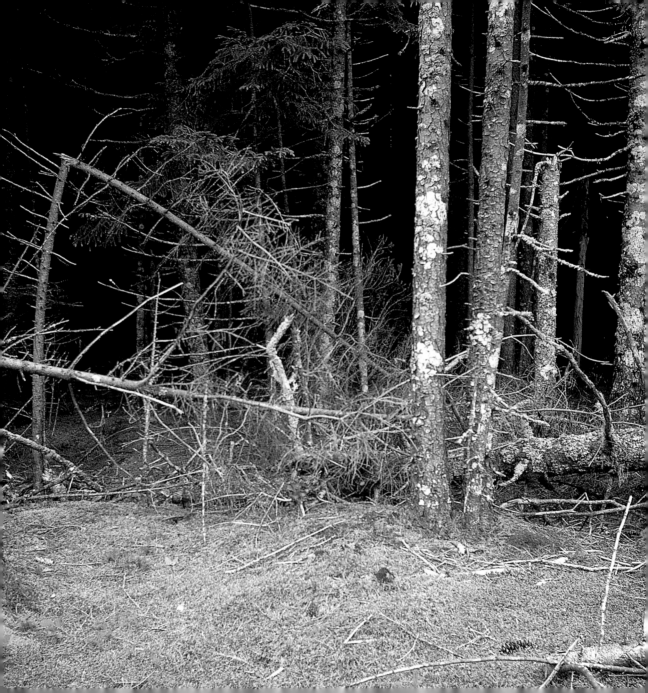

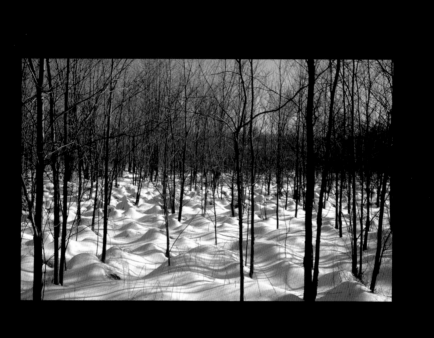

cold Cold

71

Connecticut Woods

Ridgefield

Connecticut

A misty winter's day can reveal a pristine land-

scape created by a recent snow fall. Mountain

laurels, oaks, maples, hemlock, randomly dis-

persed, are all couched in deep, still cold. No

wind, rain, or animals have yet made their mark.

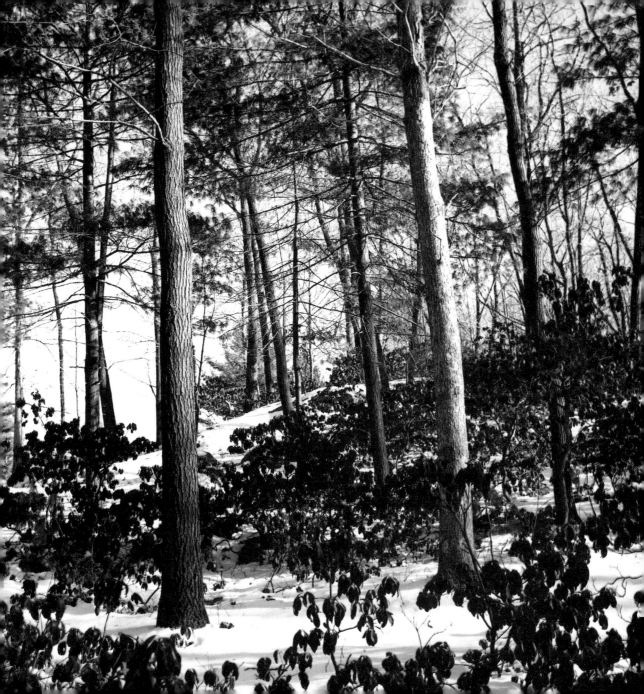

Second-Growth Woods

Chester County

Pennsylvania

The shadows emphasize the structure of the land

and make abstract shapes upon the cold snow.

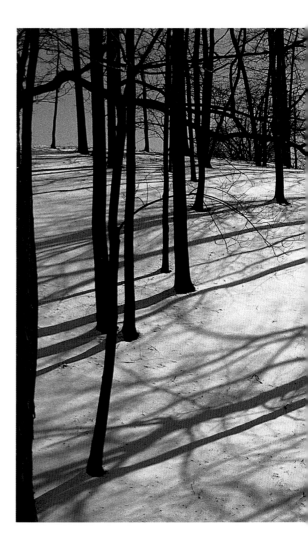

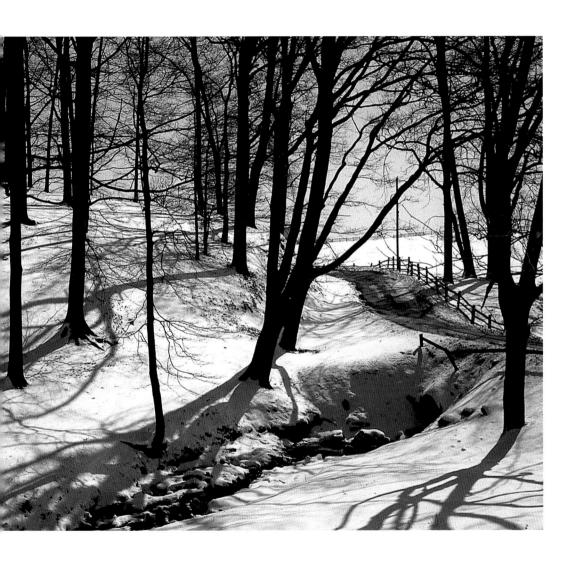

Winter Landscape

North Salem

New York

A winter landscape that is oppressively cold.

Why? Because a mist hovering above the soggy

snow means that the cold sinks in.

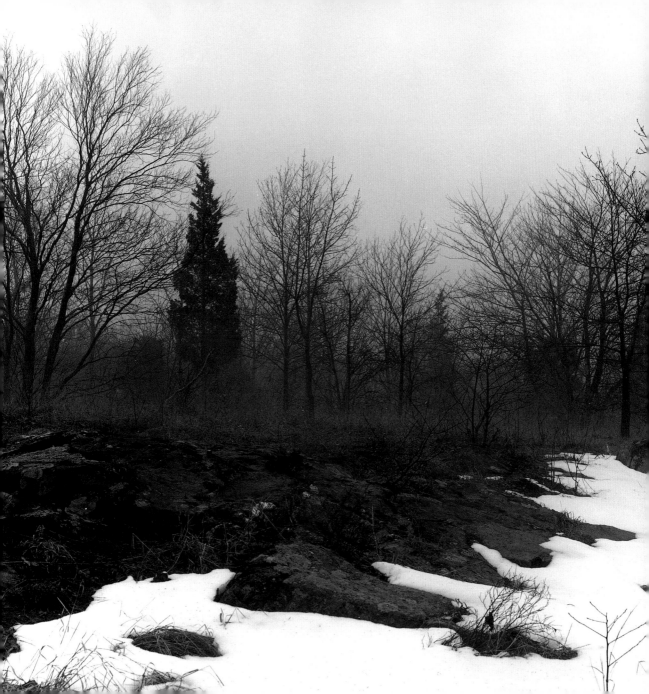

Thin Ice

Westchester County

New York

In winter we see extensive areas of delicate thin
ice along the edges of brooks and streams and
on ponds and lakes. When this occurs we only
have to look to enjoy the wonderful crystalline
abstractions that Nature provides.

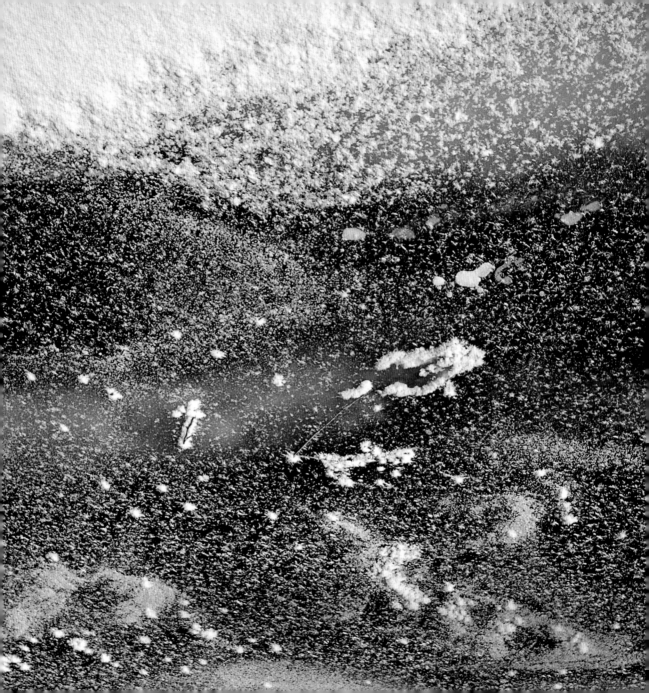

Tussock Sedge

Lincoln

Massachusetts

Not only does this bog with snow and ice suggest
a chilly landscape; it also portends a frightening
experience should you accidentally fall into the
pervading ooze.

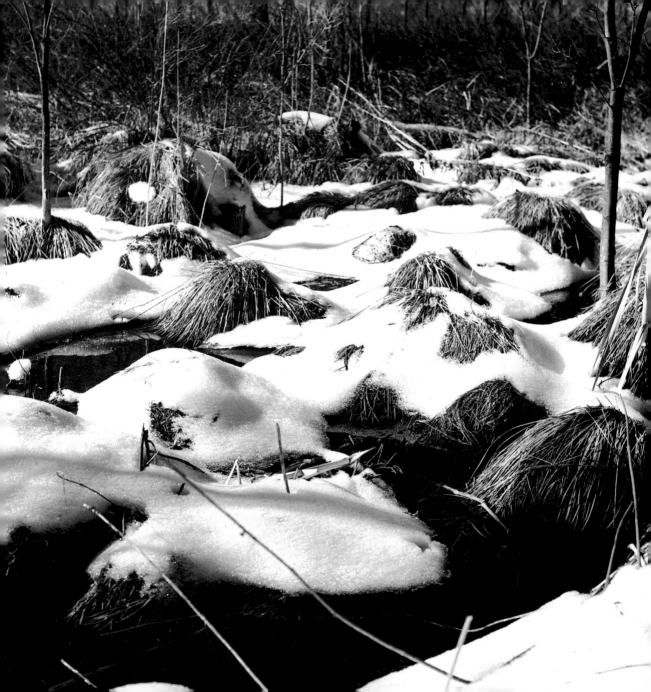

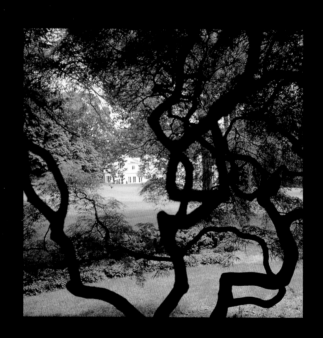

Contorted

Black Gum

Long Island

New York

Silhouetted against a fading sky these eerie

black gum *(Nyssa sylvatica)* twist and turn. Their

writhing branches give the illusion that the trees

are in constant motion.

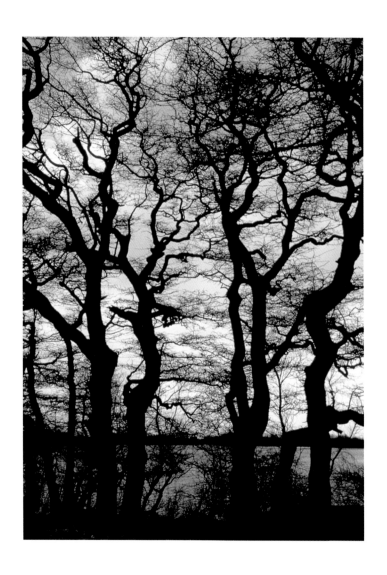

Weeping European Beech

Morris Arboretum

Chestnut Hill, Pennsylvania

Trees can grow into fantastic forms, as has this old

weeping European beech *(Fagus sylvatica 'Pendula').*

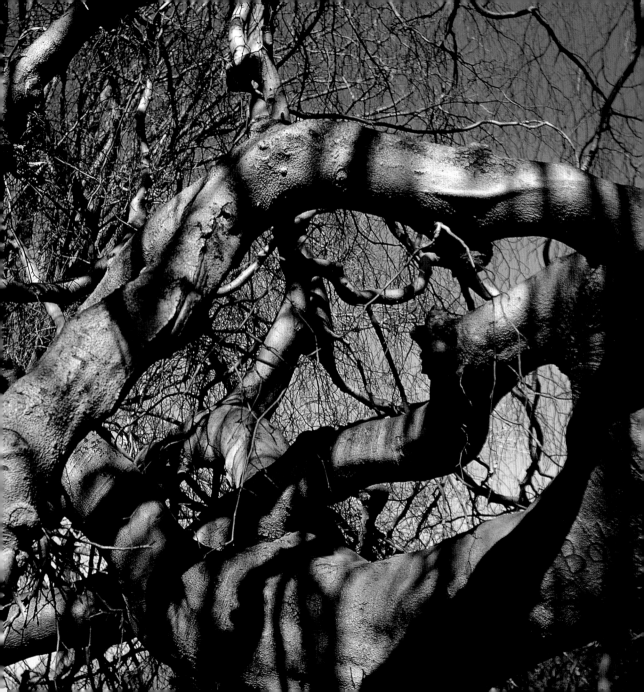

Barbara Beach

Curacao

Netherland Antilles

The trees on this beach resemble dancers con-
torting their bodies, expressing their feelings
through movement. The scene illustrates how
planting of a single species can create a variety
of effects that can be repeated in a garden.

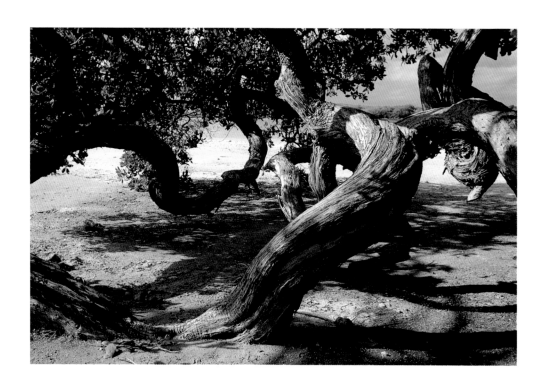

Camperdown Elms

Newport

Rhode Island

A group of camperdown elms *(Ulmus glabra*

'Camperdownii') are isolated at the edge of the sea,

where, without competition, they can easily be

enjoyed for their gyrations.

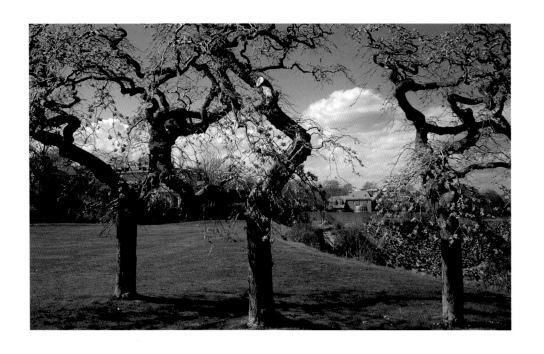

Red Cutleaf Japanese Maple

Cutting Arboretum

Long Island, New York

Imagine a hundred or a thousand of these red cutleaf Japanese maples *(Acer palmatum dissectum 'Ornatum')* twisting and writhing as a grove. It would be fantastic. The tree is at its most interesting in the winter when the foliage is gone.

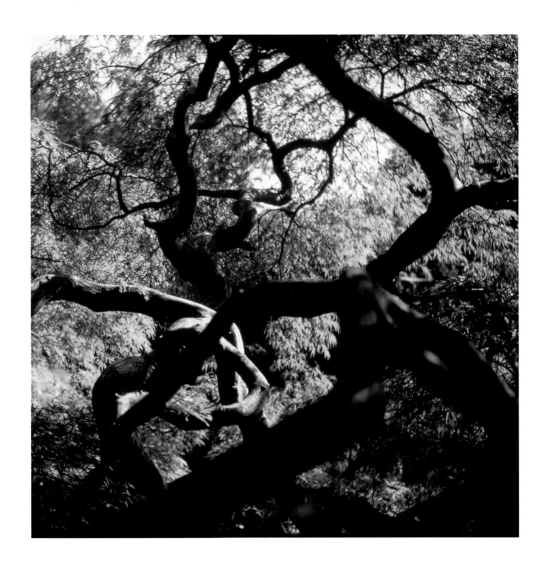

Dazzling

Phragmites in Winter

Long Island

New York

Phragmites *(Phragmites australis)* is an invasive
reed that is found in fresh or salty waters. Its seed
heads glow when low winter sun shines through
them. They remain upon the stalks all winter.

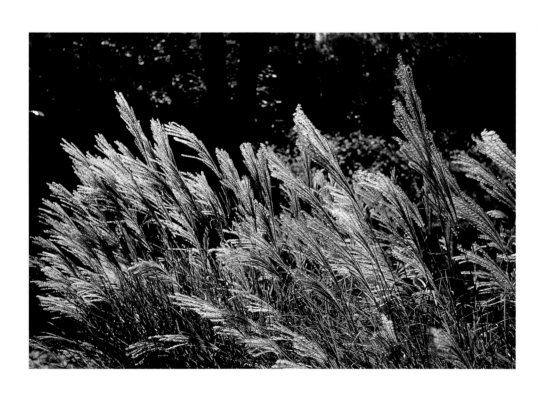

Apple Tree

Ridgefield

Connecticut

Ripe apples still dangling on the branches become

glittering ornaments against the blue fall sky.

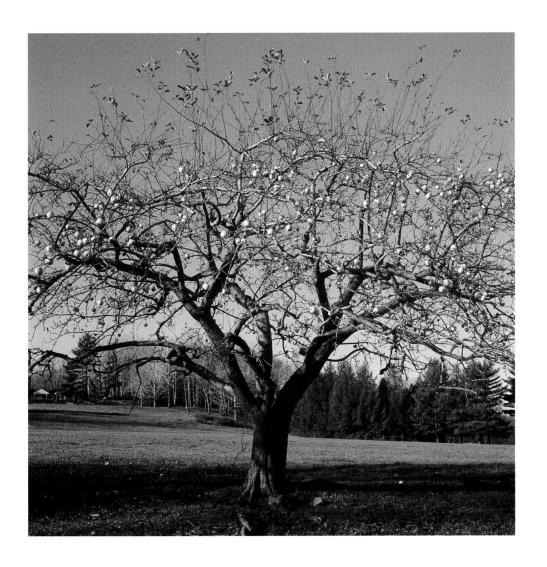

Spring Woods

Ridgefield

Connecticut

When leaves are still tender in late April and

early May considerable sunlight passes through

the foliage to give the illusion of green light in

the woods.

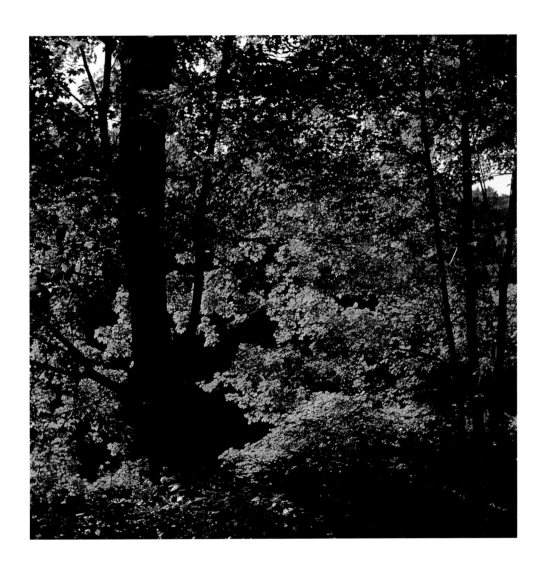

Sugar Maple

North Salem Road

Ridgefield, Connecticut

Even in a black and white portrait of a sugar

maple *(Acer saccharum)* we see bright sunlight

coming toward us through the leaves to produce

this dazzling effect.

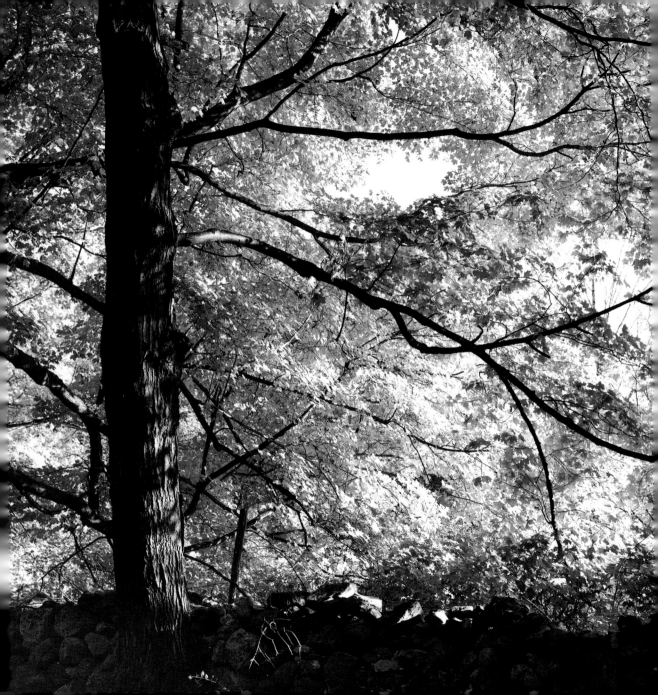

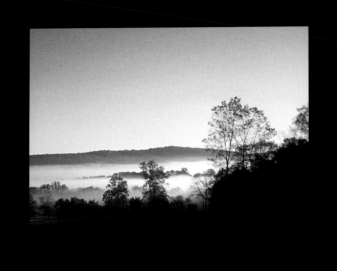

delicate

Delicate

Wild Flowers

Monhegan Island

Maine

Two conditions of time exist in Nature: the
permanent and the impermanent. One condition
serves to enhance the other. The delicacy and the
impermanence of the wild daisies become most
pronounced when they grow against a solid
outcropping of rock and a protective mass of
mature spruce and fir trees.

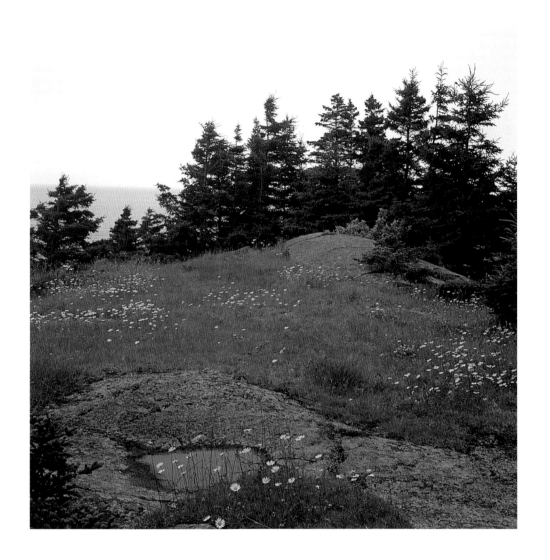

Wild Lily of the Valley

Montgomery Pinetum

Cos Cob, Connecticut

Fragile plants can be so hardy that they reappear year after year giving us a woodland floor of delicacy and fragility. Illustrated here is the Canada mayflower *(Maianthemum canadense)*, a perennial that becomes a summer ground cover in the woodlands and forests.

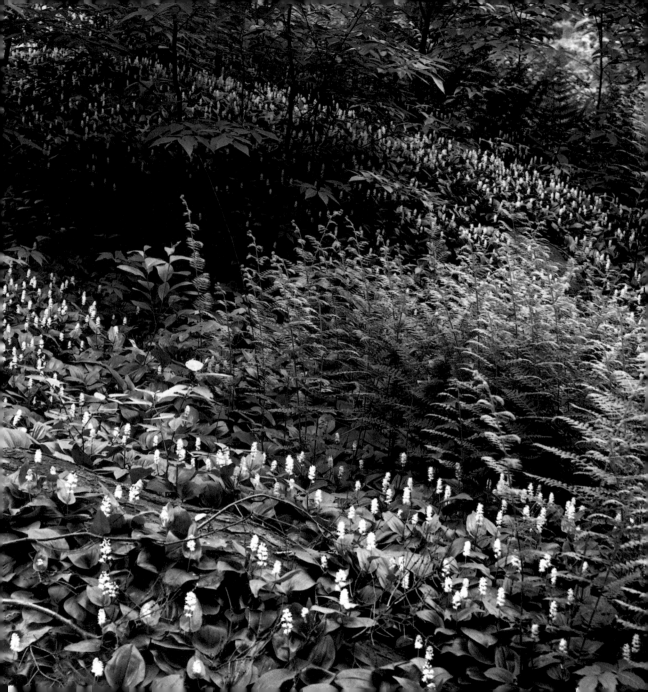

Pines

Pine Barrens

New Jersey

An exquisite fineness of texture characterizes this

forest where a myriad of thin, fragile branches

weave together into a tangled web. A single shaft

of sunlight penetrates the darkness and highlights

several delicate branches over the leaf-strewn forest

floor. *Photograph by Jane MacGuiness.*

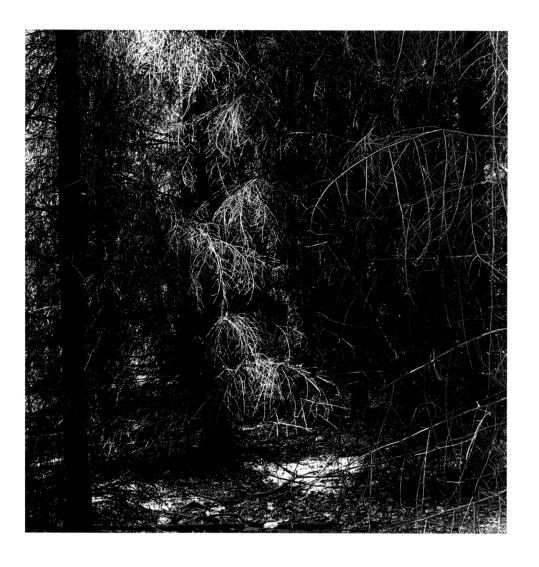

III

Black Cherry

Central Park

New York, New York

For a lacy and delicate effect overhead, look

to the black cherry *(Prunus serotina)* in winter.

The outer twigs and branches are thin and pliant

and sway easily in the wind.

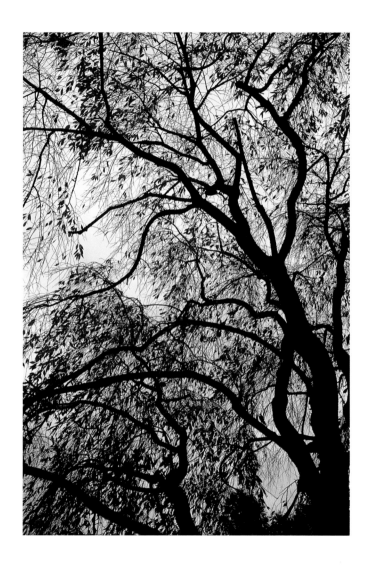

113

Water Lilies and Reeds Swedish Countryside

The swaying reeds have such fineness of

structure that they look like a veil against

the flat water lily pads.

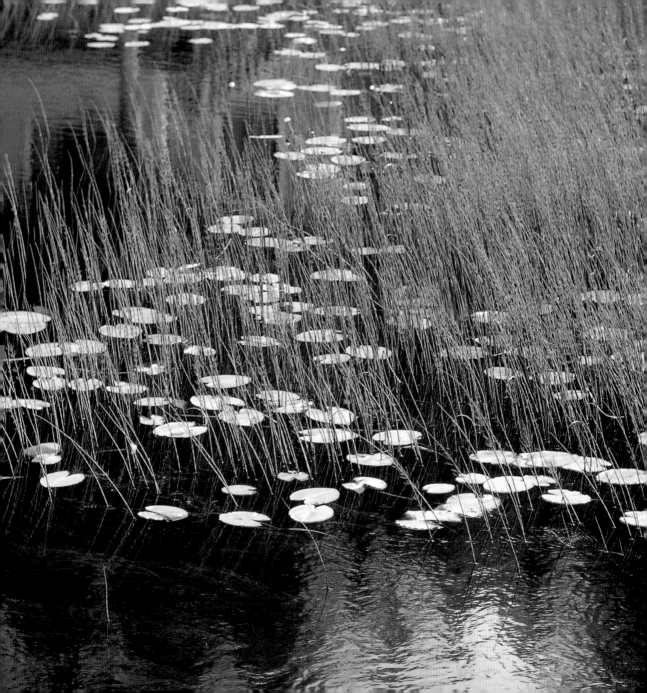

Paper Birch

Maine Seacoast

Thinning out creates a poetic composition of delicacy in tree form. The architect-owner of this property selectively cleared out a section of a wooded area to reveal the slender white forms of these paper birch *(Betula papyrifera).* These trees do not represent the typical clump-growth habit of birch.

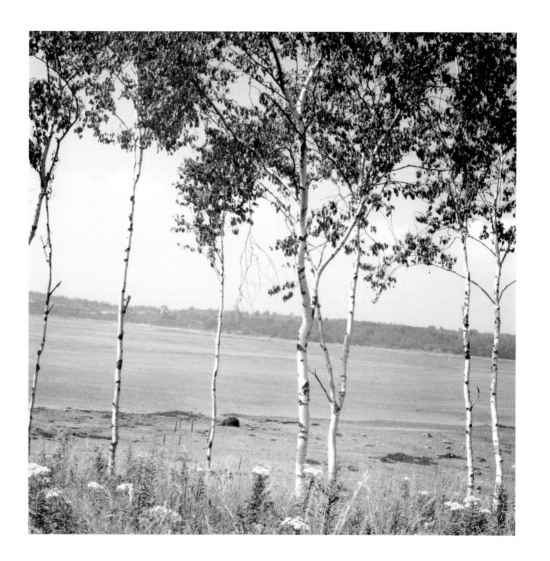

Spanish Moss

Jacksonville

Florida

The quality of the light coming toward us gives
this scene its eerie quality. Spanish moss *(Tillandsia*
usneoides) glimmers when the low rays of the sun
pass through the delicate leaves.

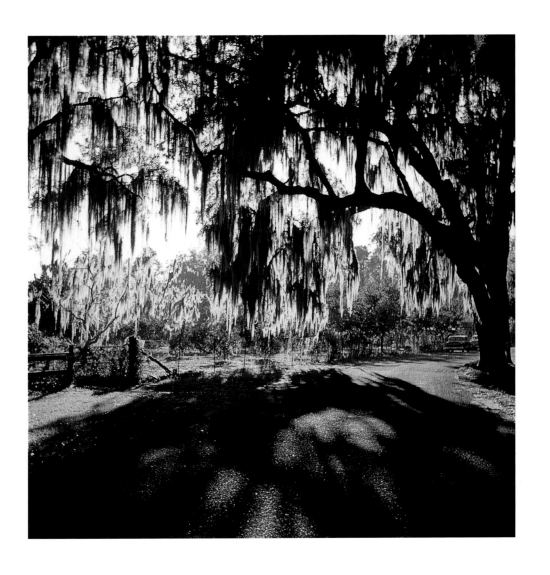

Lichens Switzerland

If we have lichen in our vicinity we should be

very appreciative of the fact. They display many,

many colors in wonderful abstract patterns on

rocks and boulders, old logs, tree trunks, walls of

buildings (whether wood or stone), stone fences

and walls, on so many things left undisturbed.

Snakeroot

It is sometimes important that a species of flower be planted alone. Portrayed is snakeroot *(Cimicifuga racemosa)* in flower. It is comparatively delicate and its slender elegance should be shown in isolation. A perennial, it grows well in shade and its leaves below the flowers make a wonderful groundcover.

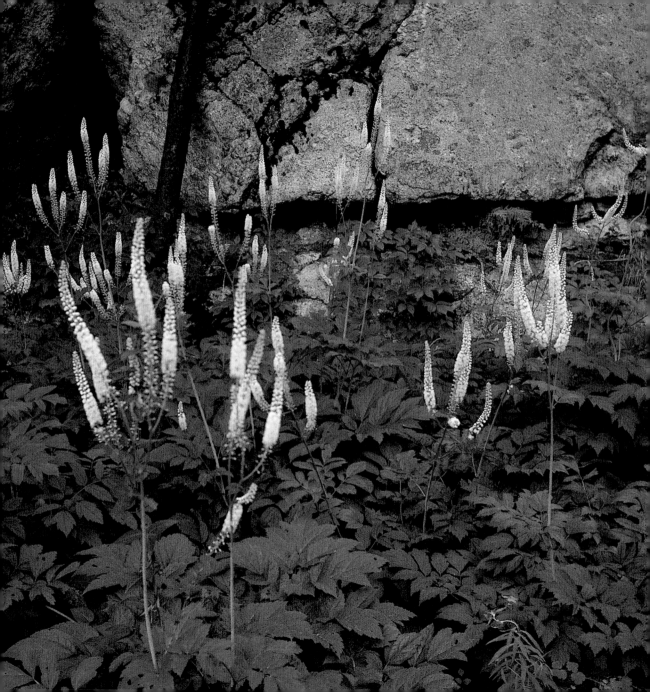

Spider Webs

Great Spruce Head

Maine

If anything has a whimsical character in

nature, it is the spiders' webs covered with

dew drops in the early morning. *Photograph*

by Michael Weymouth.

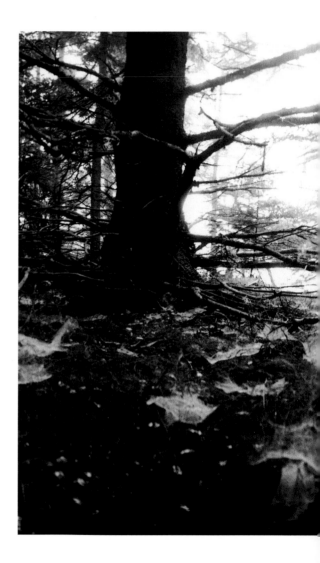

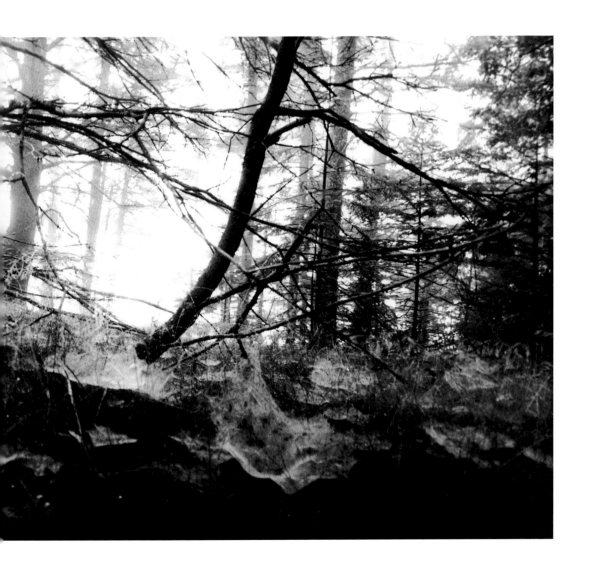

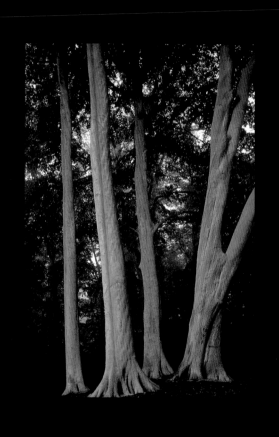

elegant

Elegant

127

Hemlock Boughs

Connecticut Countryside

The dark needles and branches of the Canada

hemlock (*Tsuga canadensis*) against the mist

suggest a solemn hush.

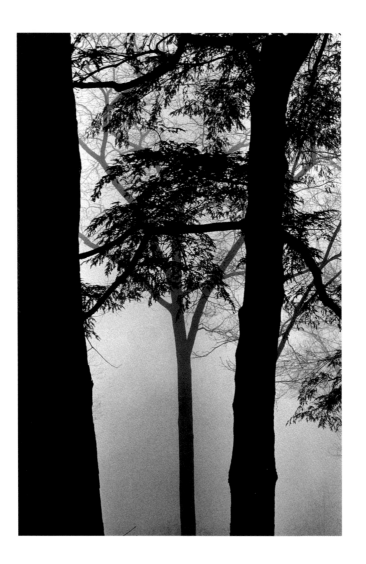

Weeping Willows

Ridgefield

Connecticut

Does any other tree suggest such softness of
spirit? The famous title *The Wind in the Willows*
carries the essence of its nature to our minds.
Easily grown in wide open places, especially near
streams and edges of ponds, weeping willows stay
in bright leaf longer than any other deciduous
tree in the northern landscape.

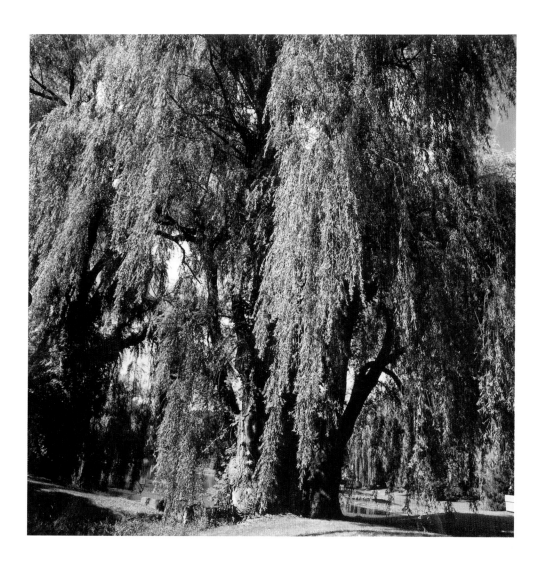

Second-Growth Forest

Connecticut Countryside

When deciduous trees grow in a second-growth

forest their closeness forces them straight up

often producing slender and eloquent forms.

Photograph by Jane McGuiness.

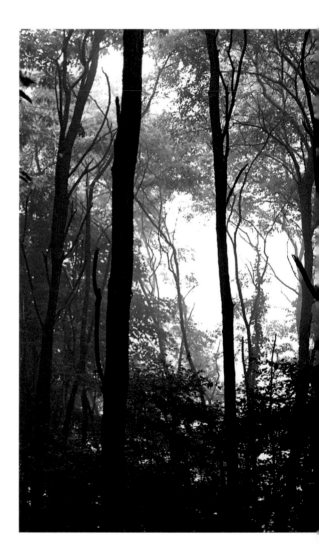

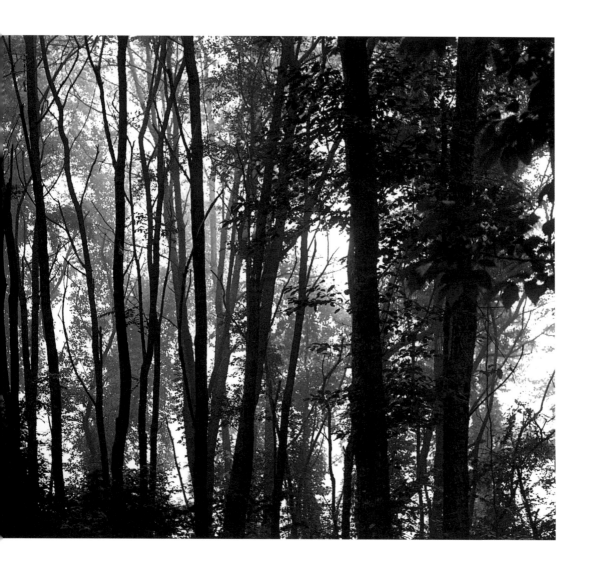

Tulip Trees

Scarsdale

New York

Stateliness can easily be achieved by planting,

in groves, the tulip tree *(Liriodendron tulipifera)*.

Given time the trees will grow straight and tall

and live a long time.

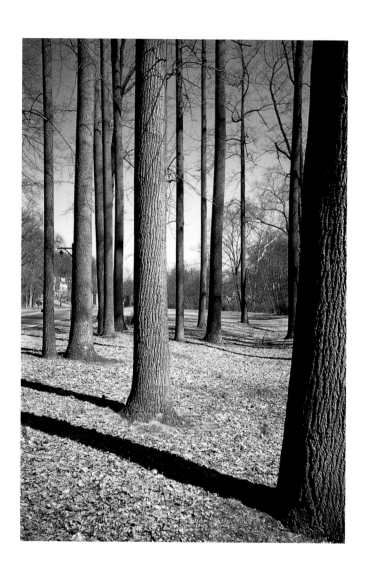

Cypress Trees in a Cemetery

The word *dignity* springs to my mind when I try to describe the tall columnar cypress *(Cupressus sempervirens)*. They are powerful exclamation points of verticality and darkness in the bright rolling countryside of southern France. Cypress symbolize eternity and prolonged life and can be used to locate cemeteries and churches in the countryside. Their marvelously dense forms create splendid hedges when planted closely together.

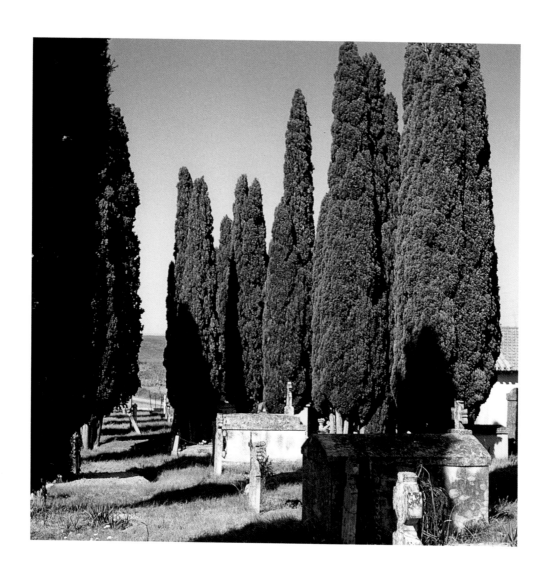

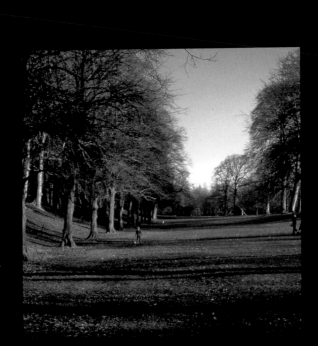

Friendly

Abandoned Meadow

Ward Pound Ridge Reservation

Cross River, New York

An abandoned meadow reverting back to a

woods evokes warmth and friendliness with

the orange and rusty color of its tall grasses.

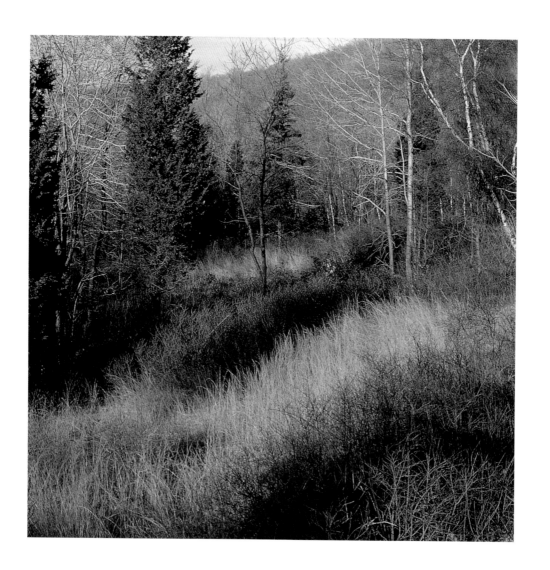

Daisies at a Private Residence

Woods Hole

Massachusetts

A narrow granite walk embraced by daisies
provides an inviting and cheerful walk to the
front door. The daisies literally lean outward and
forward to greet us as we slowly make our way.
Such visual delights and fragrant elements should
be considered in the design of a garden path.

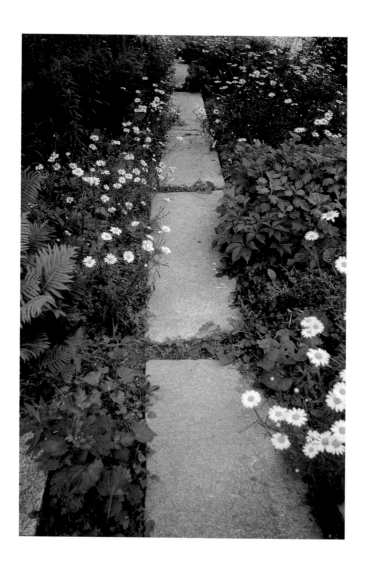

143

Beach Plum

Red Cedars

Highbush Blueberry

Lowbush Blueberry

Black Cherry

Martha's Vineyard

Massachusetts

This meadow of native plants of Martha's Vineyard has sprung up in free abandon, to be sure, and with the delight of things to come: beach plum *(Prunus maritima)*, blueberries *(Vaccinium),* and black cherry *(Prunus serotina).* A real wildlife garden where all plants are naturally compatible with each other.

The Path

146

Although the woods are dense and dark and a

forbidding place to walk, the path is free of

obstructions. It invites strolling along so that we

can see the fishes, turtles, and snakes that live

here. A wonderful place for children.

Paper Birch

Taconic State Parkway

New York

An abundance of paper birch *(Betula papyrifera)*

growing as a single species in a woods convey

a certain gaiety, summer or winter. Especially

so when they are bathed in sunlight on a

cloudless day.

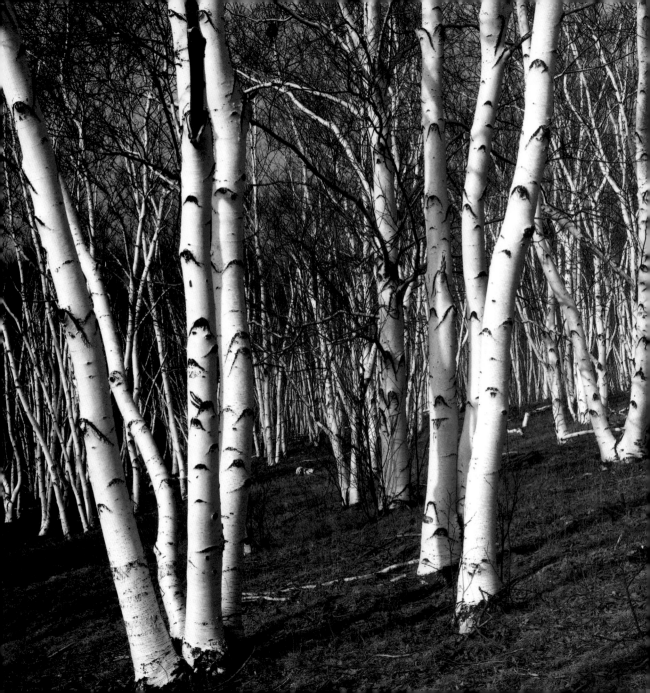

Wild Flowers

Monhegan Island

Maine

The landscape of a fishing village is often composed

of the remnants of the fishing trade: pieces of rope,

discarded anchors, lobster buoys and traps, old

boards, drying nets, and paraphernalia of many kinds.

A certain charming mess. Yet there is delight in

seeing wild flowers—living things—soften the drab-

ness of the scene. There is also a touch of warmth

and humor where the yellow flowers pick up the

yellow in the buoys hanging freely against the traps.

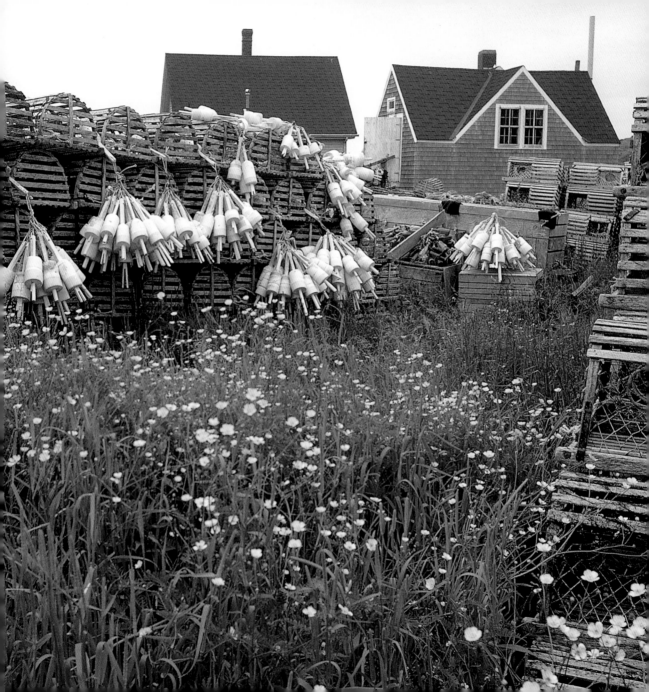

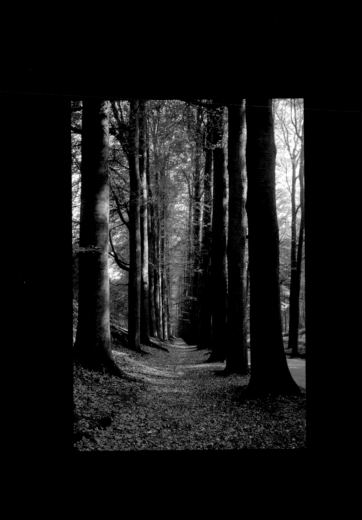

grand

Grand

153

Oak and Beech Trees

Wilmington

Delaware

Competition? No. It is fair play among the mature trees of the forest. Each plays its part according to its nature. The oaks discard their lower branches when confronted with too much shade; the beeches do not. Their destiny is fulfilled in a park that allows them to achieve great size.

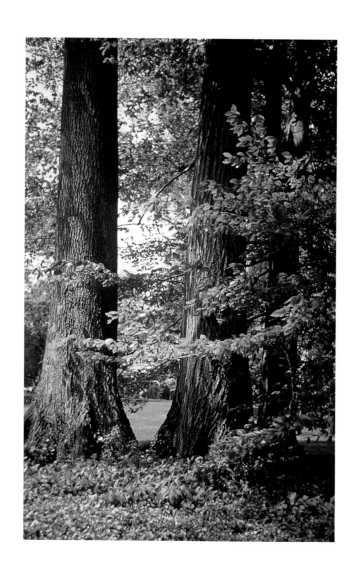

Old Beech Tree

Brussels

Belgium

We don't see old beech trees very often. It takes a
hundred years or more for them to reach great girth
and height. An old European beech *(Fagus sylvatica)*
with a trunk diameter of over six feet stands alone
with considerable grandeur and majesty.

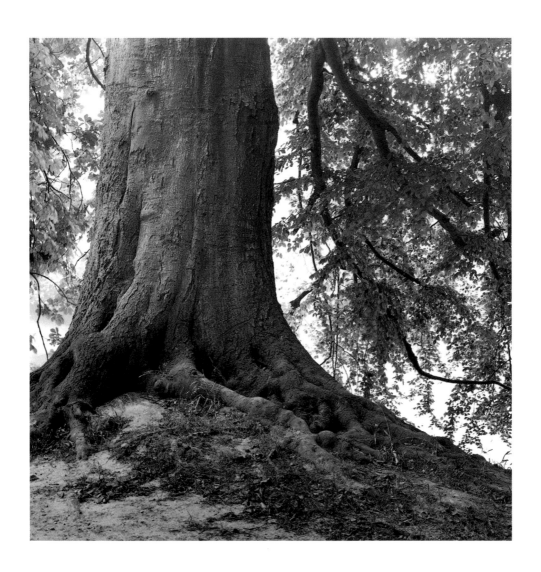

European Beech Trees

Royal Botanical Gardens

Meise, Belgium

This eerie scene is the result of a light gray-
greening of the trunks of these European beech
(Fagus sylvatica). They stand alone against a somber
woods and assume a grand prominence in a
dreary landscape.

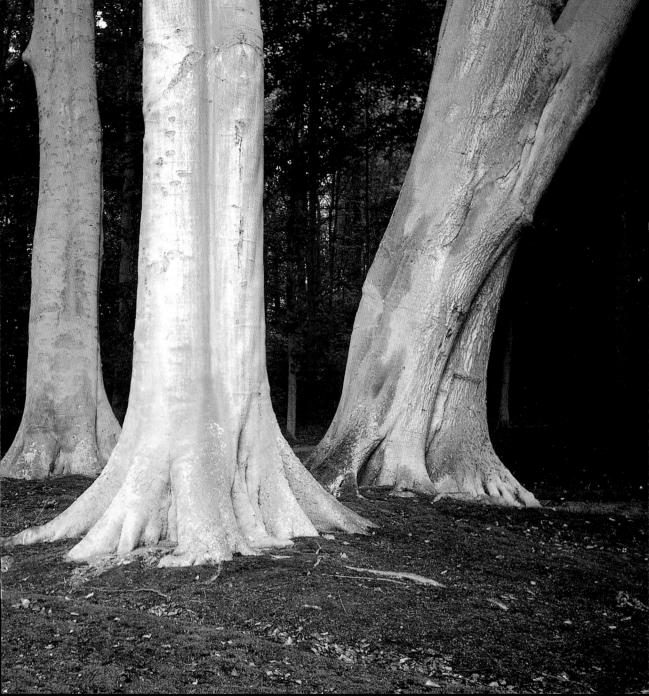

A Grove of Oaks

Delaware County

Pennsylvania

We see grandeur in all these trees, large and small,

with their straight growth accentuated in this

case, by the snow. We see optimism. They are well

spaced; the small ones will be able to grow and

eventually replace the old. The character of this

landscape should last for decades.

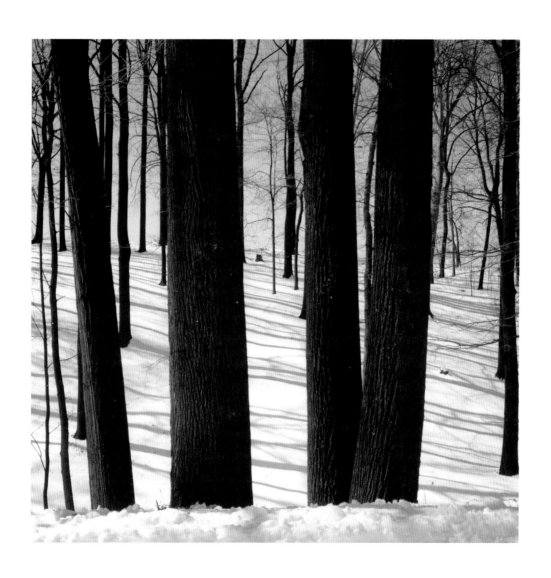

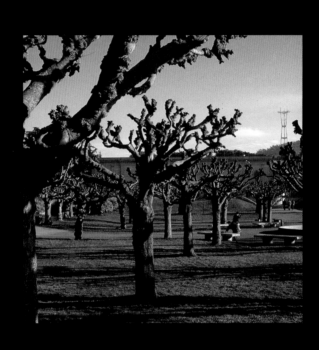

grotesque Grotesque 163

Willow Tree

Saw Mill Parkway

New York

An old willow *(Salix alba)* has been hit by a

disease. Probably the Crown Gall.

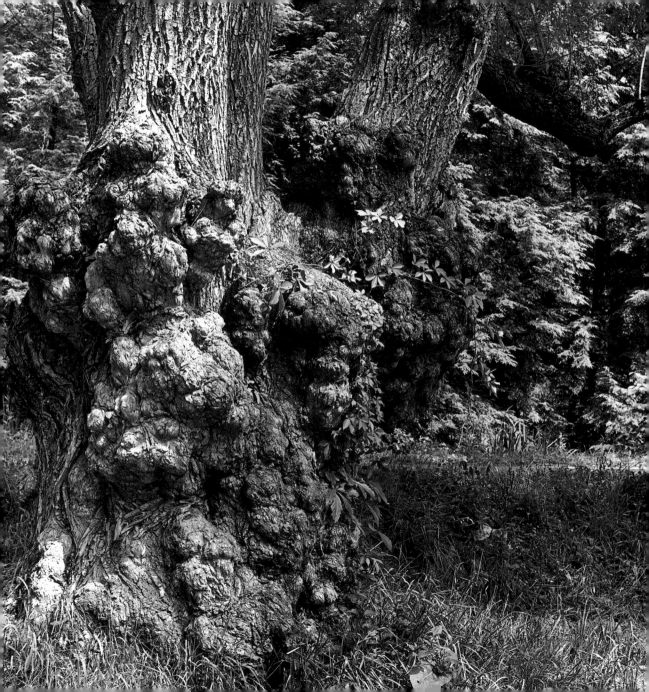

Woods

The Alps

Switzerland

The grotesque is rather prevalent in what is old,

decaying, or subject to diseases and to harsh

conditions, either by the hand of man or Nature.

Or it can simply be the nature of the thing. This

scene is a metaphor: you see a horrible face.

Maybe someone you know!

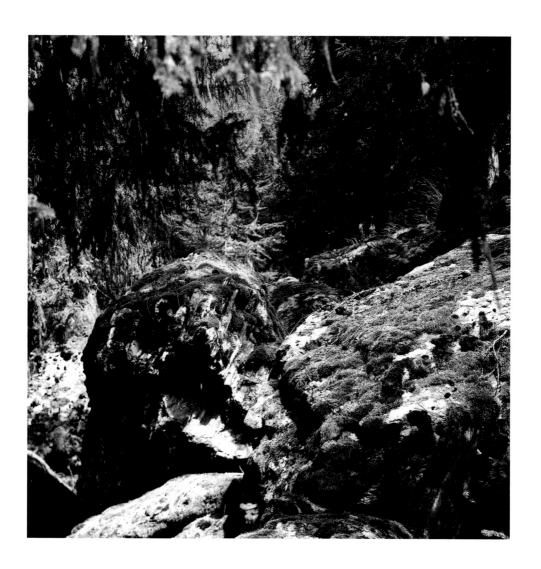

Legend Tree

Bonaire

Netherland Antilles

Some trees are cherished for their grotesquery—

in this case "The Legend Tree," which grows on

the shore of Bonaire, an island of the Netherland

Antilles. It has been dwarfed and twisted by

ceaseless salty winds usually blowing from one

direction. It is so unusual that the citizens prize

it and take care of it.

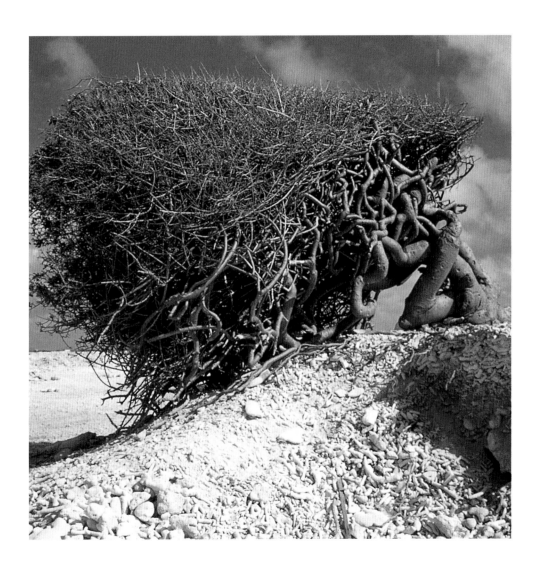

European Larch

The Alps

Switzerland

This European larch *(Larix decidua)* is obviously

suffering from the smothering effect of an

uncontrolled growth of lichen.

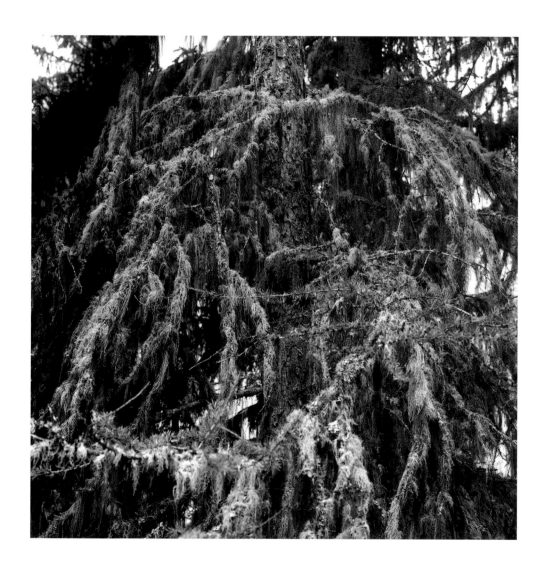

Grape Vines Connecticut

How monotonous our land would be if we
never utilized the strange and unusual! Let grape
vines climb up dead trees, boulders, fences, over
banks and small hills. In October they contribute
substantially to the autumn colors.

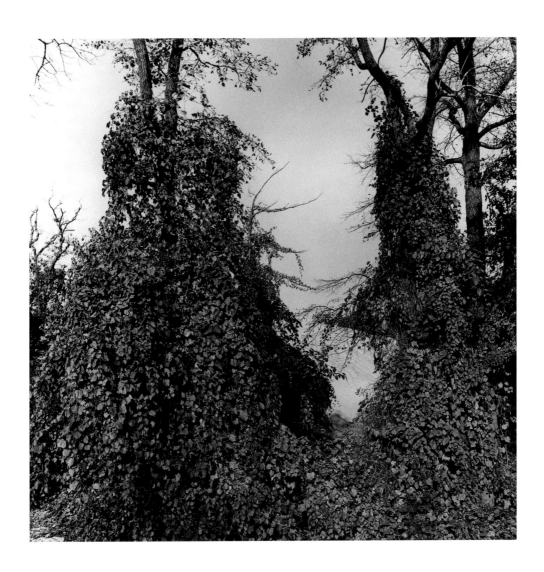

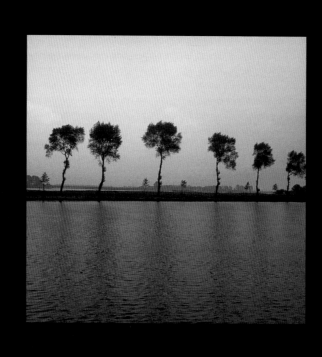

humorous
Humorous

Cactus

Curacao

Netherland Antilles

176 Like so many rabbits scampering across

the meadow.

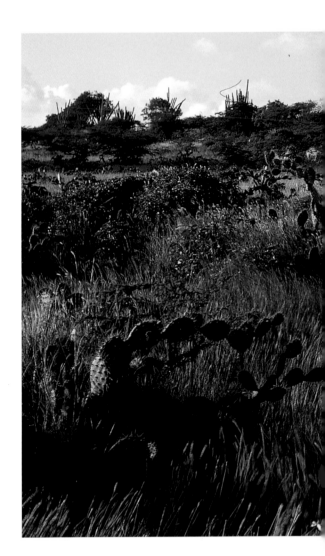

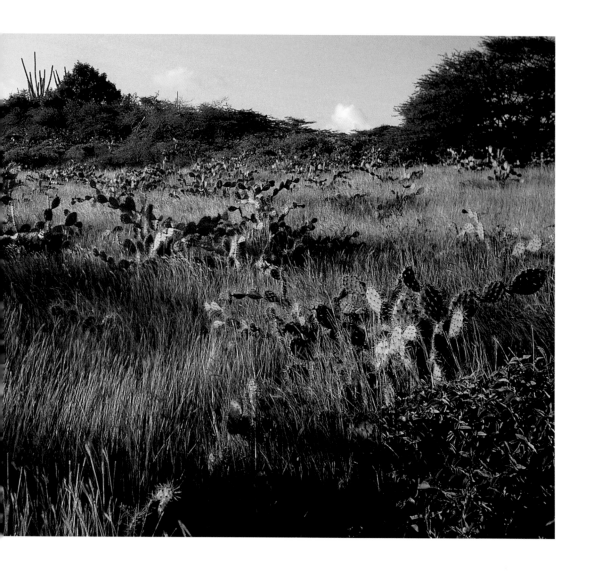

Rotting Log in a Marsh

Pine Barrens

New Jersey

Some would find this ominous; to me it is

disconcertingly benign. Close to humor: a scene

a child would delight in.

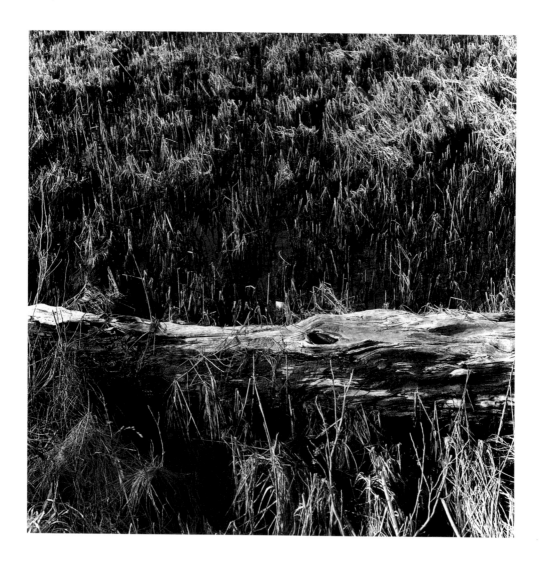

Pollarded Willows

The Netherlands

Trees of several kinds have been pollarded for centuries. These willows have been pollarded to produce willow wands for making baskets. The resulting appearance looks incongruous: a thick top to the trunks with delicate branching above. Quite humorous!

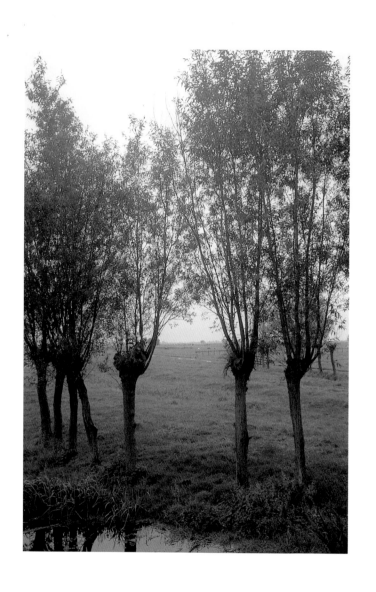

A Bog

Bedford

New York

Snow rests humorously on clumps of Tussock

Sedge *(Carex stricta)* growing in a wetland area.

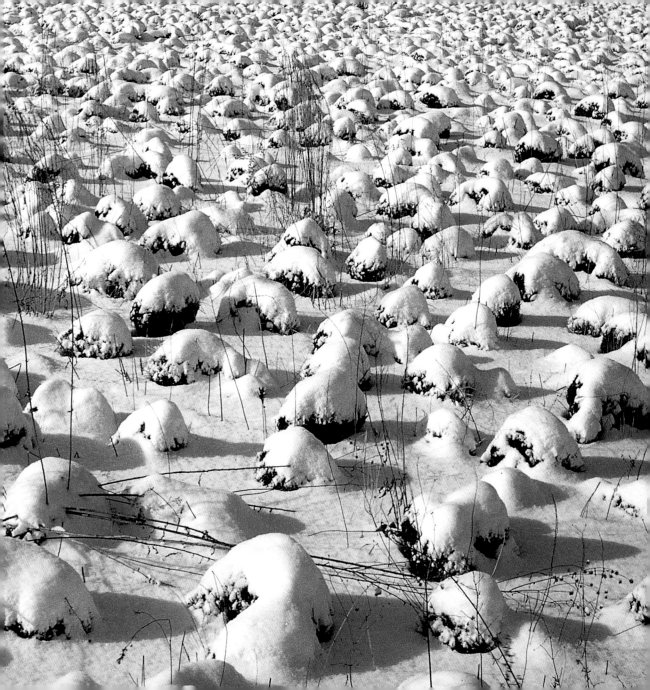

Boulders on the Seacoast

Peggy's Cove

Nova Scotia

These boulders along the eastern coast of Nova

Scotia appear haphazard in their association with

each other—like so many seals on a beach.

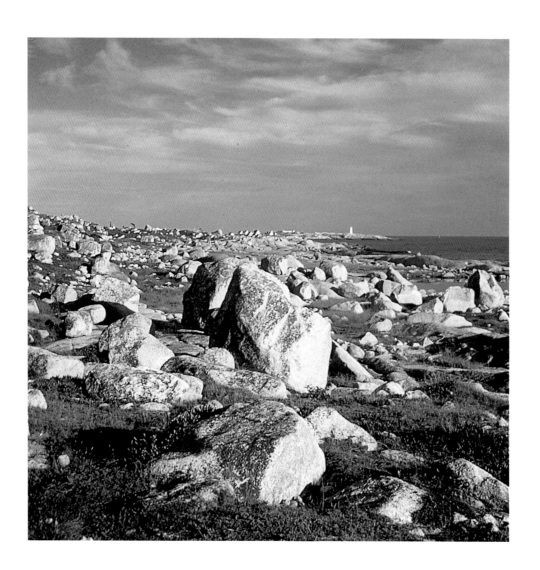

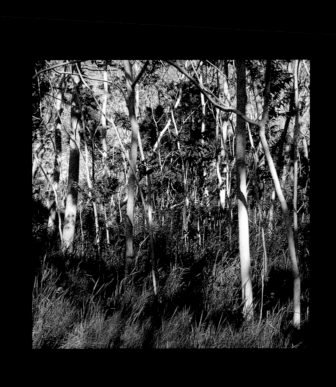

lively
Lively

Uncut Meadow

Hingham

Massachusetts

How lively when the wind blows upon

the uncut grass!

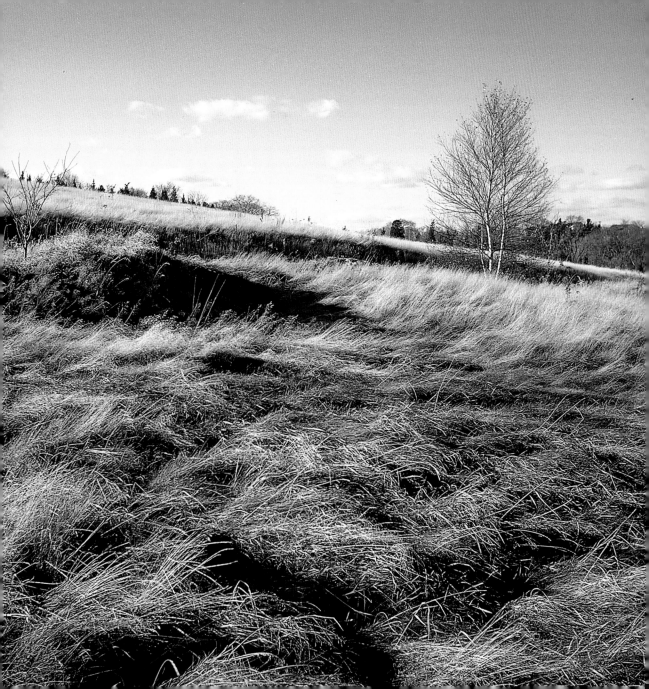

Stream Sweden

The water lily leaves, broad and flat; the reeds,

slender and long, swaying against the current.

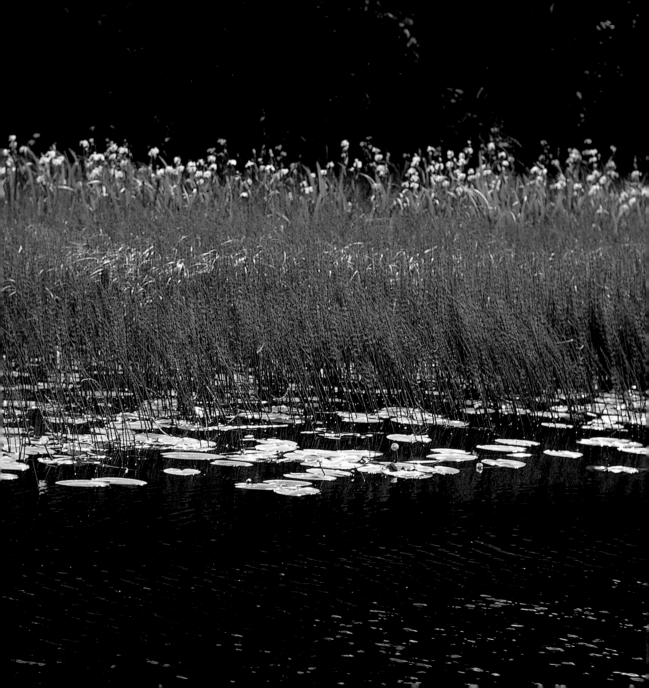

Smooth Sumac

Southampton

New York

So sprightly is the smooth sumac *(Rhus glabra)*

in winter when the dark red seed cones dangle

tenaciously upon the tops of the slender branches.

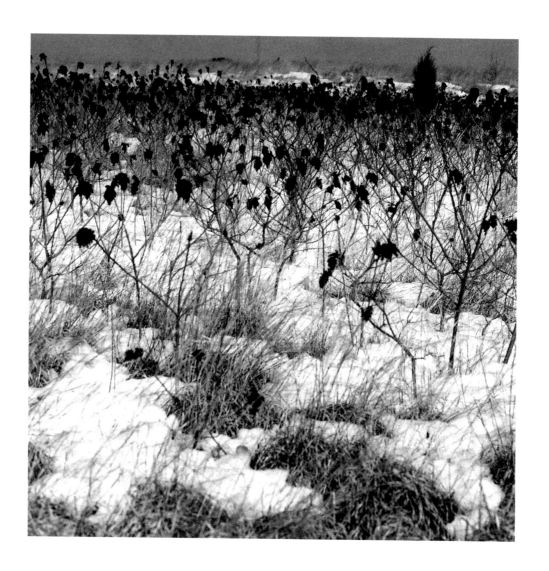

193

Paper Birch

Taconic State Parkway

New York

A tightly grouped planting of paper birch

(Betula papyrifera) twist and turn against the sky.

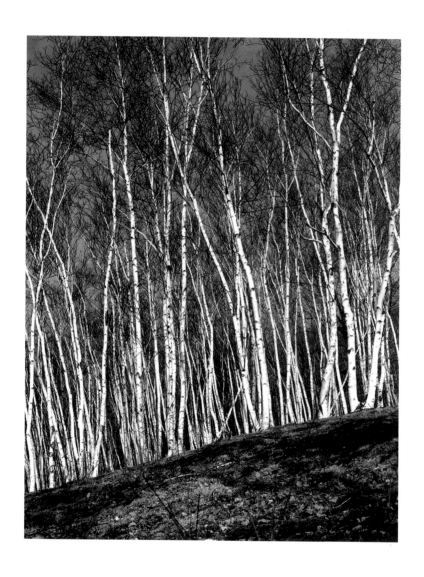

Katsura Tree

Morris Arboretum

Chestnut Hill, Pennsylvania

A katsura tree *(Cercidiphyllum japonicum)*, even in
its old age, exhibits considerable gracefulness with
its sinuous branches snaking outward from a
massive trunk. We see this in winter when we
can enjoy the beauty of its structure.

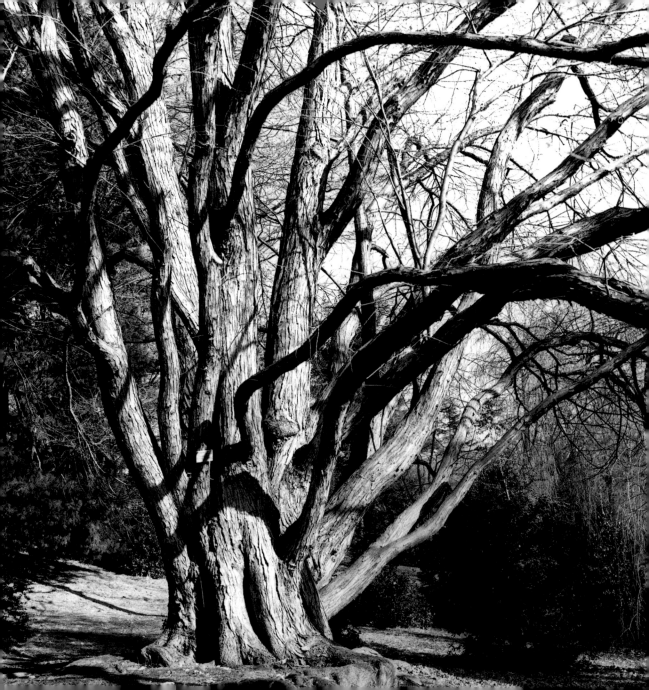

Winter Grass and Snow

Westchester County

New York

We too often think a winter's landscape without
snow as dull. When warm hues of grass rise above
the snow, we can imagine an enlivened landscape
of striking color through the whole of winter.

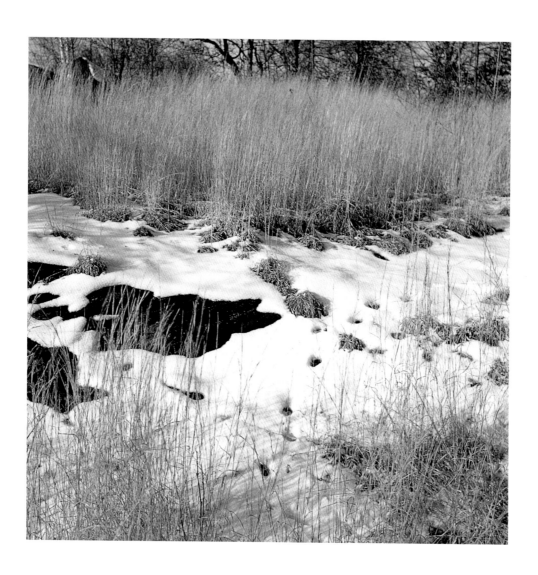

A Marsh

Ridgefield

Connecticut

Be not dismayed to find algae on the surface of

your pond. It produces wonderful greens that

enrich the landscape scene with sinuous shapes:

a summertime event.

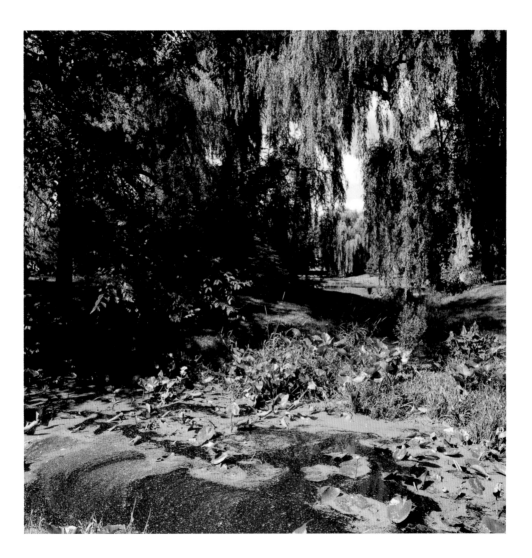

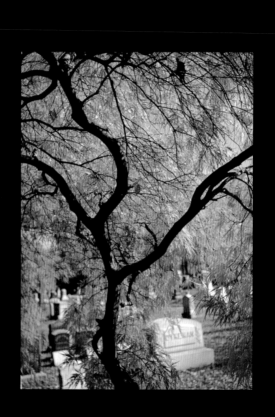

luminous Luminous

Poplars

Southern France

Sheer poetry in southern France where passing
cloud shadows direct our attention to the side
lighting on the slender poplars.

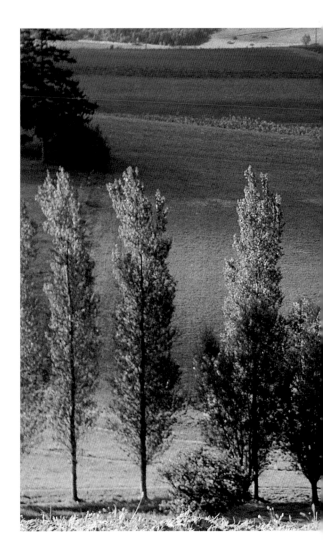

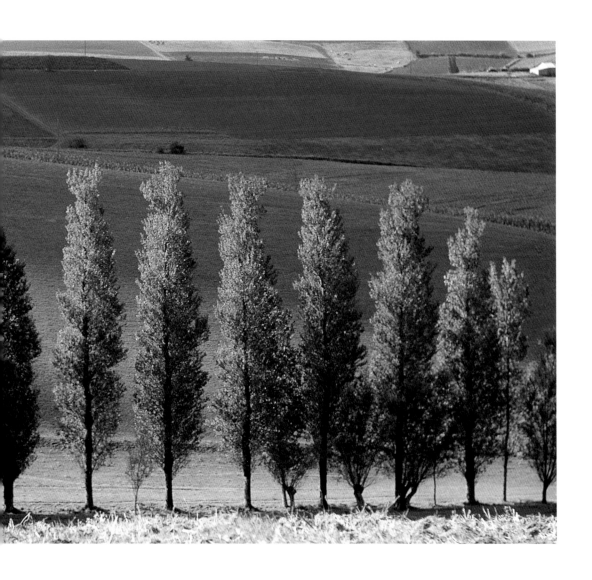

Honey Locust

Chicago

Illinois

A single large honey locust *(Gleditsia triacanthos)*
illuminated by bright sunlight brings cheer to a
dark architectural canyon. The tree absorbs the
rays of the sun and, in turn, radiates them in all
directions with its leaves: a pronounced effect
of foliage luminosity. The dark background of
the buildings has etched out the tree for this
startling effect.

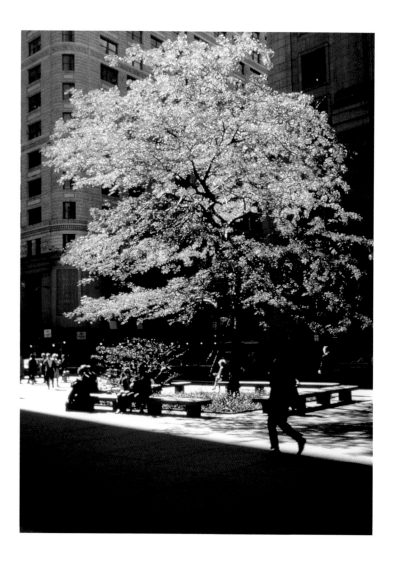

Meadow

Ridgefield

Connecticut

The disorderly arrangement of rocks and boulders

that once formed a stone fence, and the dark

undulating masses of the billowy trees in the back-

ground provide a framework that enhances the

brightness of the fine-textured meadow grasses.

An otherwise staid landscape is enlivened through

this opposition of forces: hardness and softness,

lightness and darkness. It is, above all, a landscape

possessing the quality of luminosity.

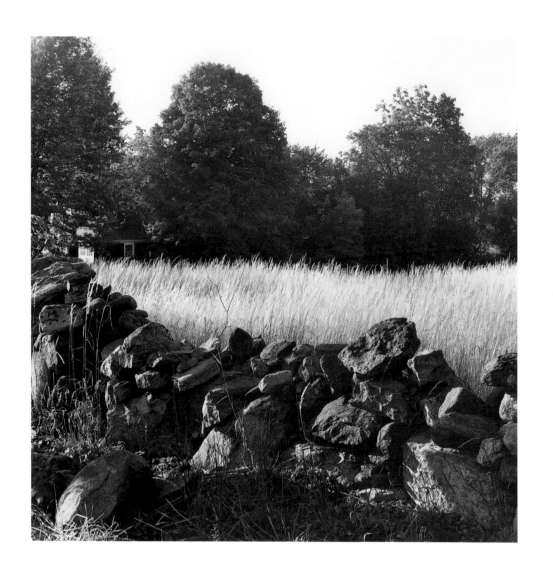

Weeping Willow

Ridgefield

Connecticut

A startling portrayal of sunlight, brightens

the pendent foliage of a weeping willow

(Salix babylonica).

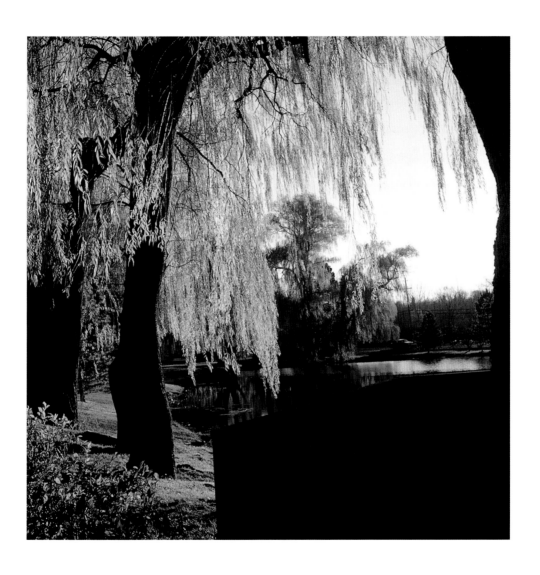

Wild Mustard

Swedish Countryside

With no obvious light source evident in the
photograph, the glowing field of mustard
appears to be lit from below. The vast spreading
of this colorful plant can lighten the heart of
the passerby. The layers of cool color in the
distance also create the illusion of greater depth
and make the sea of yellow seem brighter.

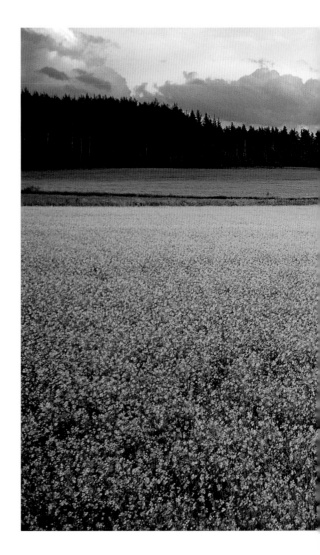

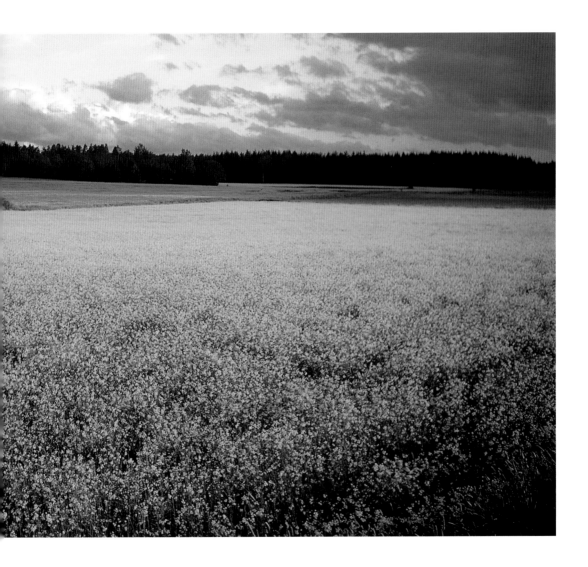

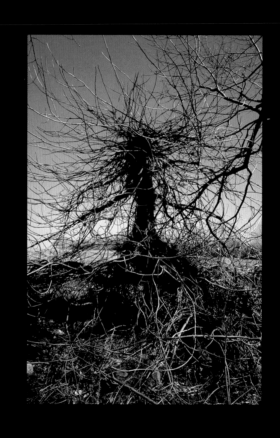

malevolent Malevolent

215

Cactus

Curacao

Netherland Antilles

The photograph says it all. Who would want to venture through such a formidable environment? Yet, for many, it is fascinating to stare at what is inhospitably repulsive.

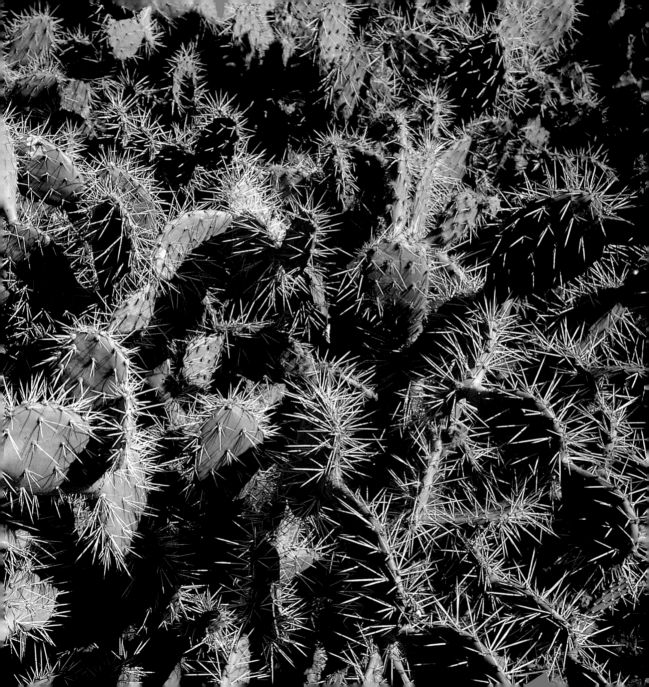

The Okefenokee Swamp

Georgia and Florida

The Okefenokee Swamp is mysterious and malevolent. Its corridors of canals have no apparent destinations, nor do the woods offer any strong points for orientation. The uninitiated can get lost. The Okefenokee Swamp is dangerous. It harbors poisonous snakes, bears, and alligators. There are thunderstorms. Yet it is a beguiling wilderness for those who love adventure in the out-of-doors.

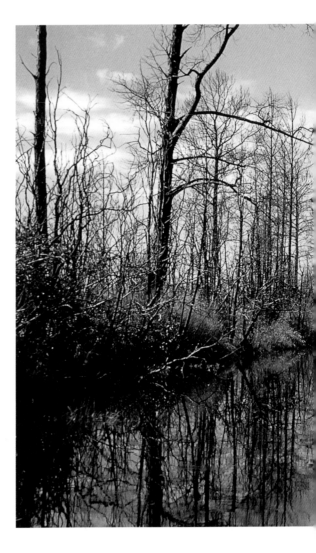

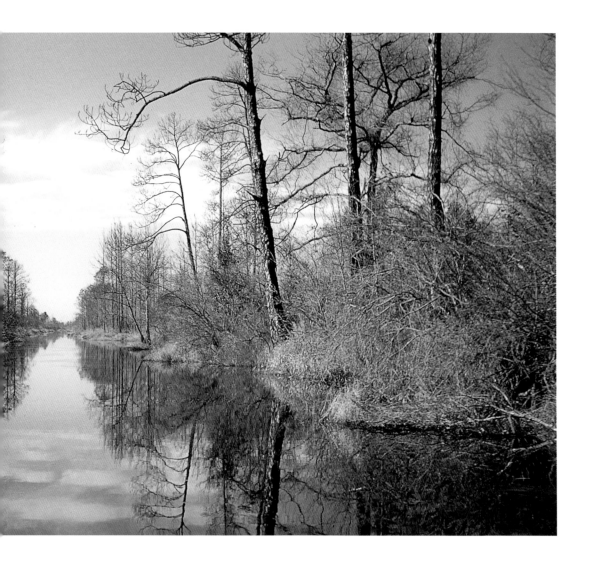

Marsh

Connecticut Countryside

This is a marsh, different from a swamp where the water flows and different from a bog where the water stands still. It is somewhat like a lake but thick with vegetation and often with fallen trees and rotting logs. It is treacherous—if you fall into a marsh when you are alone, you could sink away to oblivion.

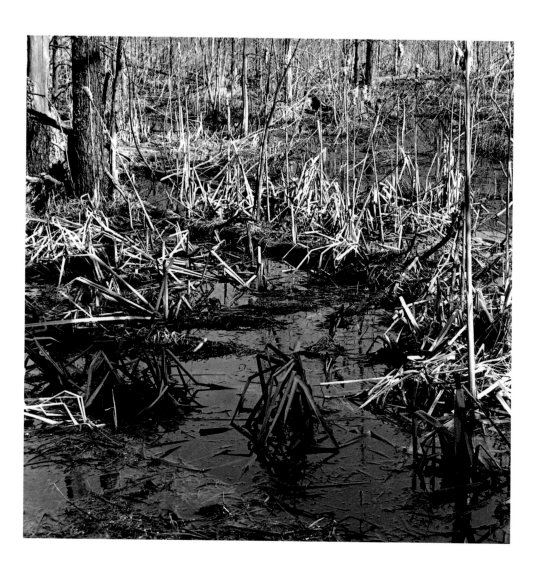

A Malevolent Tree

Cutting Arboretum

Long Island, New York

A particularly menacing effect is achieved in

this contorted moss sawara cypress *(Chamaecyparis*

pisifera 'Squarrosa') by the presence of one small

"eye." So watchful, it looks like an octopus over

its tentacles, waving in many directions.

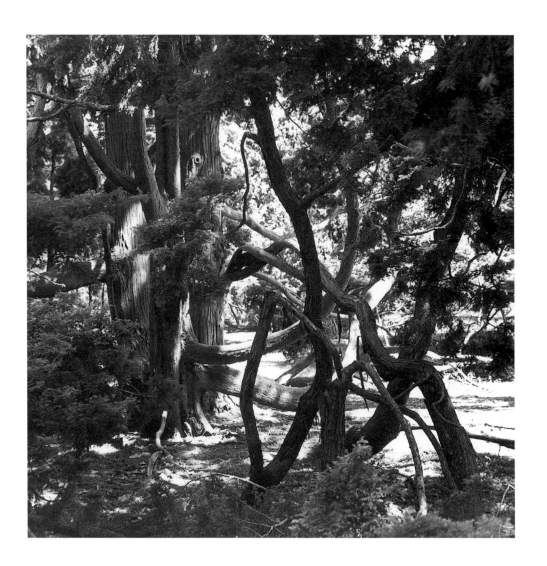

A Ruin

Curacao

Netherland Antilles

A house in ruin: abandonment, resentment,

anger, danger.

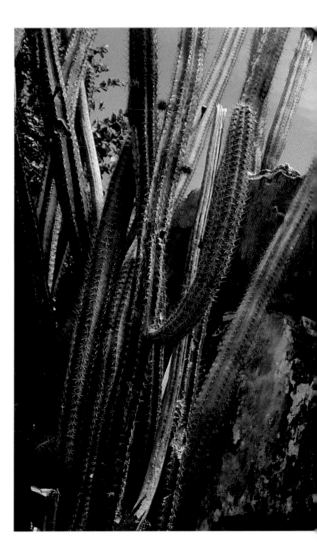

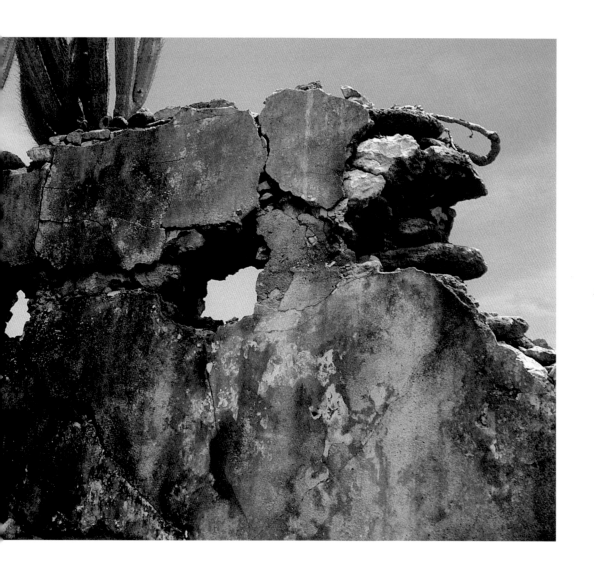

American White Cedar Swamp

Woods Hole

Massachusetts

Brilliant sunshine quickly sinks into the

forbidding darkness of the swamp's black water.

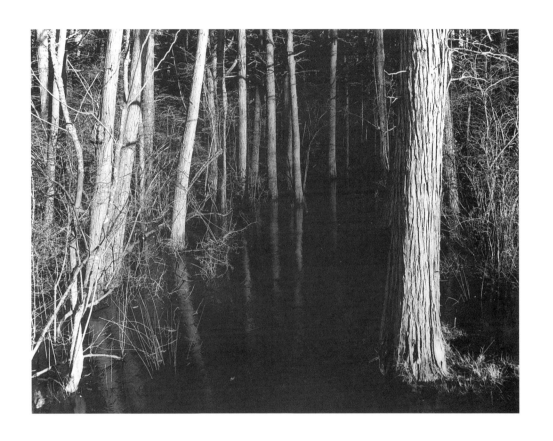

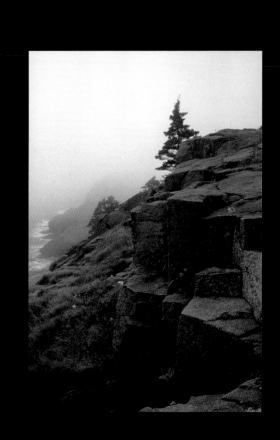

melancholic

Melancholic

229

White Pine

Near Sharon

Connecticut

A striking example of a tree expressing melancholia: A tall white pine *(Pinus strobus)* stands isolated in a bleak landscape.

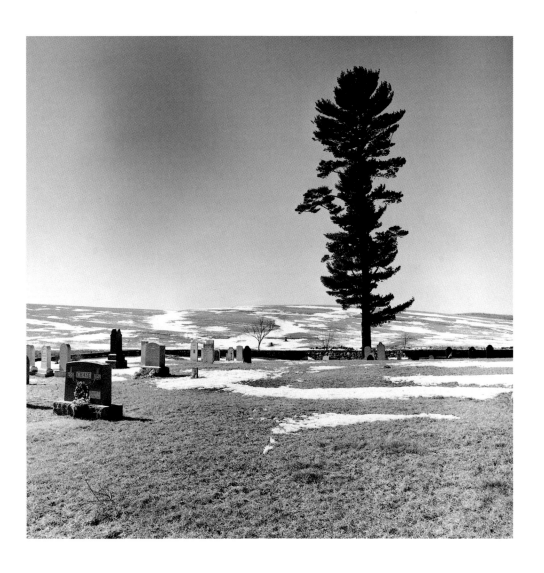

Countryside Nova Scotia

A forlorn landscape, to be sure, yet untainted.

Rugged and harsh, it evokes a somber mood.

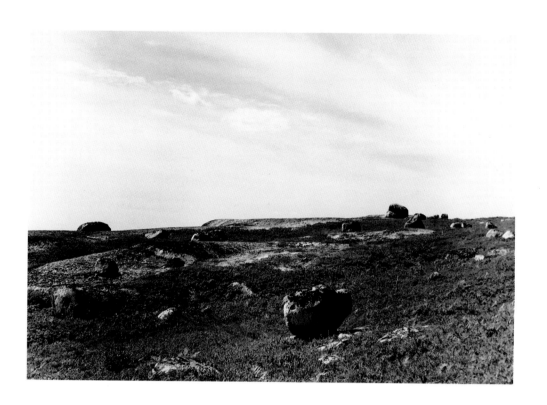

233

Woods

Ridgefield

Connecticut

In this melancholic scene, mist subdues the forms
of objects in the distance; textures are lost, colors
are grays and blacks, and what we see are only
silhouettes. In the foreground, dark masses of
boulders make a gloomy landscape ever gloomier.

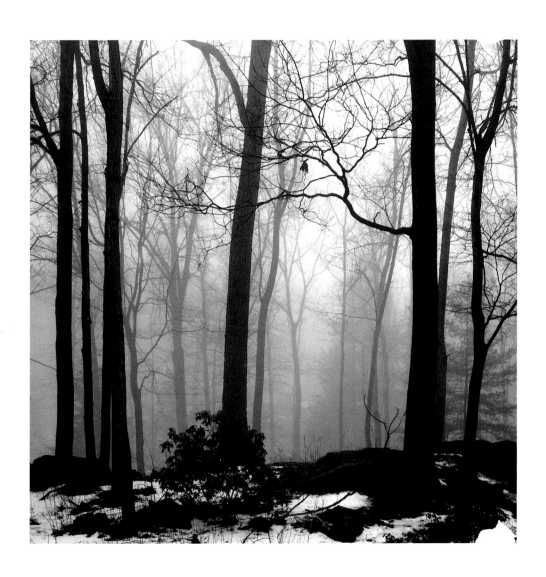

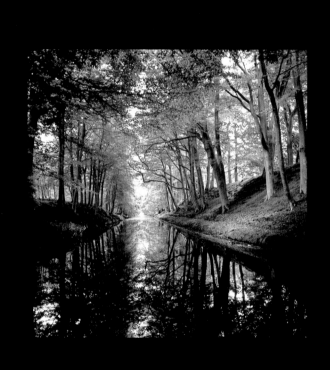

Mysterious

237

Swamp

Ridgefield

Connecticut

Swamps can be mysterious when things are
obscured by heavy vegetation and darkness. Even
in winter when sunlight slopes through the naked
trees much remains hidden. In this swamp in
Ridgefield we discern only vaguely what is there.

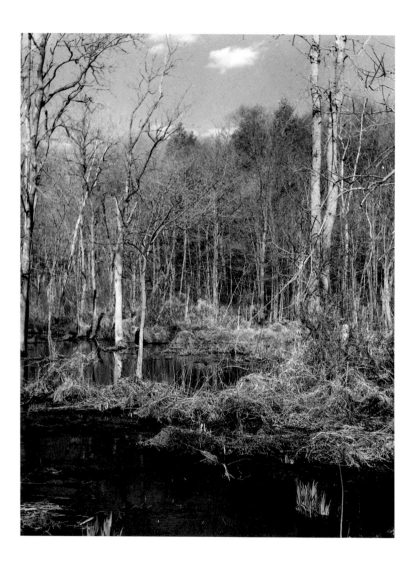

The perplexing question is why these

European beech trees *(Fagus sylvatica)* were

planted so close together. Yet this double

row elicits considerable fascination.

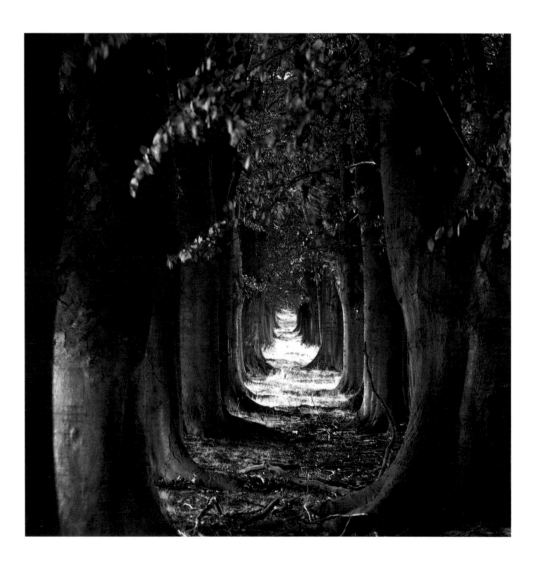

Spruce Forest Switzerland

When the dimming light turns the thick

woodland darker and darker, in direct proportion

does our imagination grow.

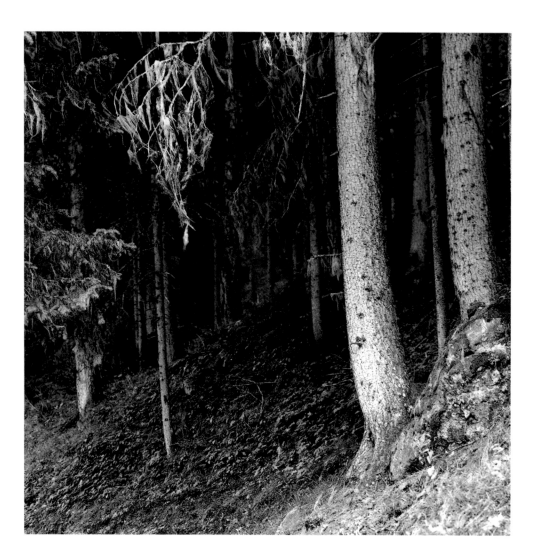

Woodland Path

Great Spruce Head Island

Maine

A striking example of mystery in a landscape:
The woodland path turns quickly to the right
behind an obstructing boulder. *Photograph by
Michael Weymouth.*

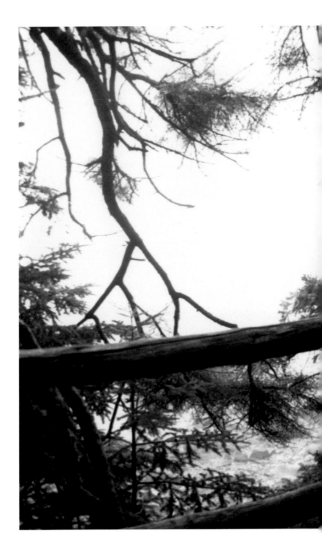

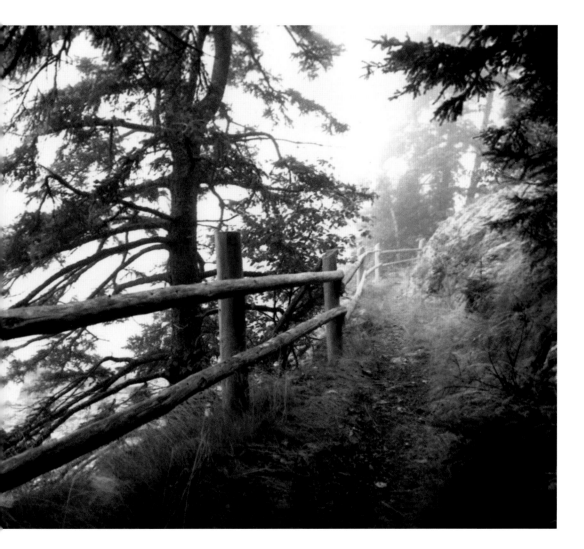

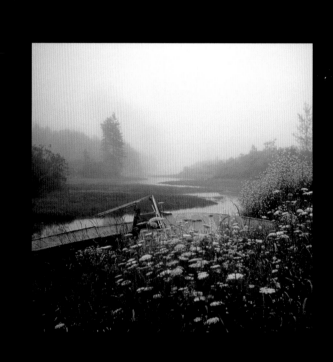

serene Serene 247

Sand Dunes

Provincetown

Massachusetts

Gentle undulations of the dunes and the grasses lend a tranquil quality to the landscape. But we know that this is a temporary composition; the next harsh wind will change the configurations. The character of the dunes will, however, remain.

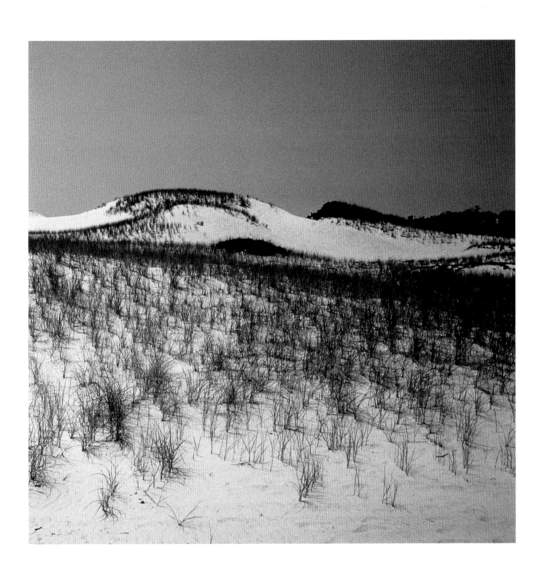

249

Meadows

Port Clyde

Maine

The dominant mass of the dark spruce and fir leads our eyes across still waters to a meadow on a private island. This is a common scene along the Maine coast. Here a design has been reinforced by the contrast between the dark masses of the forest and the voids of the meadows.

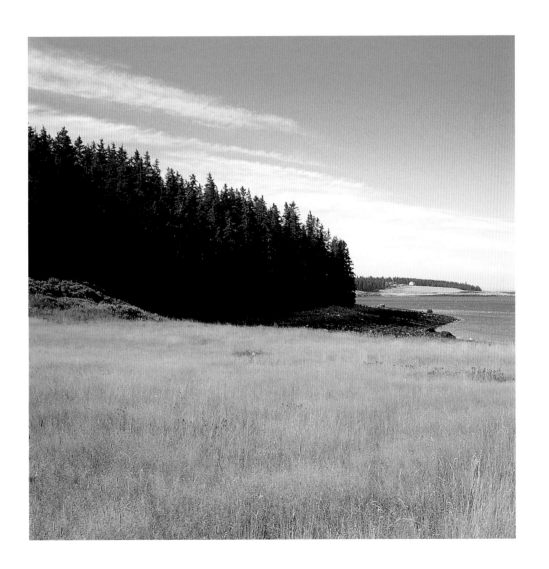

Royal Botanical Gardens

Meise

Belgium

Massive groves of mature European beech *(Fagus sylvatica)* and London plane trees *(Platanus acerifolia)* in this park in Belgium define a serene space. It is created by the high walls of the foliage and the diminishing curves of the walks as they disappear out of sight. These forces compel the curious and the adventurous to move forward to see what lies beyond. Serenity develops from the cool colors, the soft outlines, and the flowing green grass.

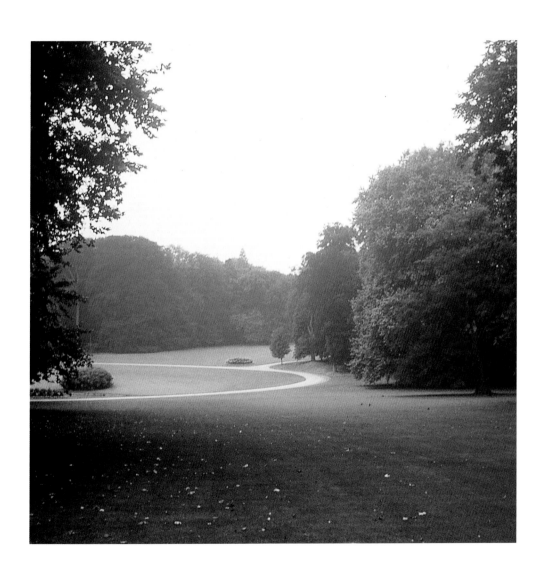

253

Near Wilmington

Delaware

An astonishingly serene effect is achieved by a

thin line of old sassafras *(Sassafras albidum)* trees

isolated against an open background. *Photograph*

by Armistead Browning.

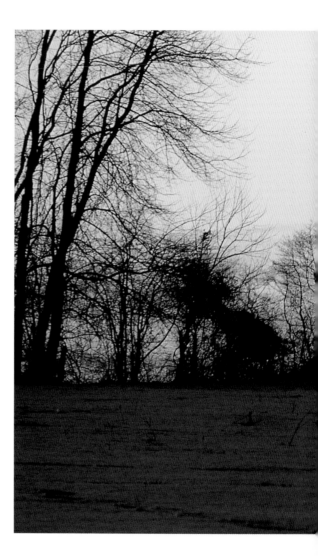

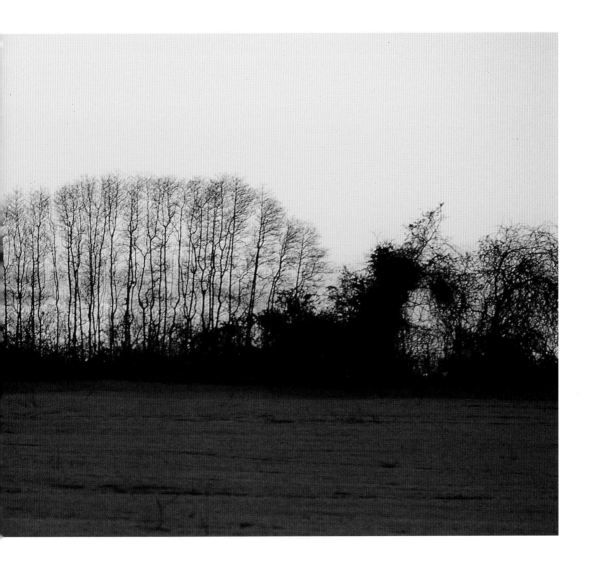

255

A Quiet Walkway A Park in Belgium

A place of stillness: no wind. A place of shade: no

harsh sunlight. A place of softness: smooth curves

and a sandy walk.

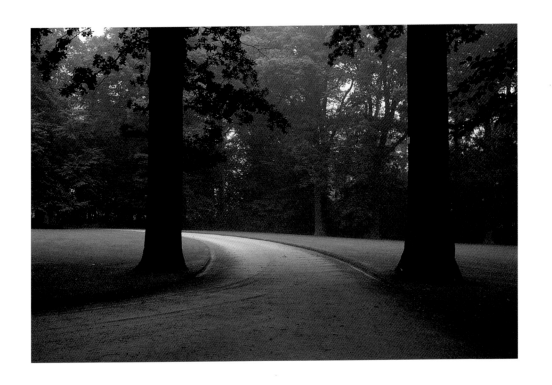

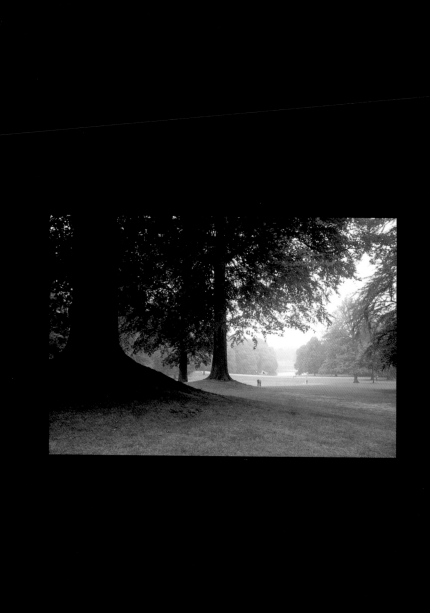

sheltering

Sheltering

European Beech Trees Belgium

260

For aeons, trees have provided shelter for

humans and animals alike against the forces

of rain, wind, and sun. In this scene the huge

European beech *(Fagus sylvatica)* offers protection

in a very pronounced way.

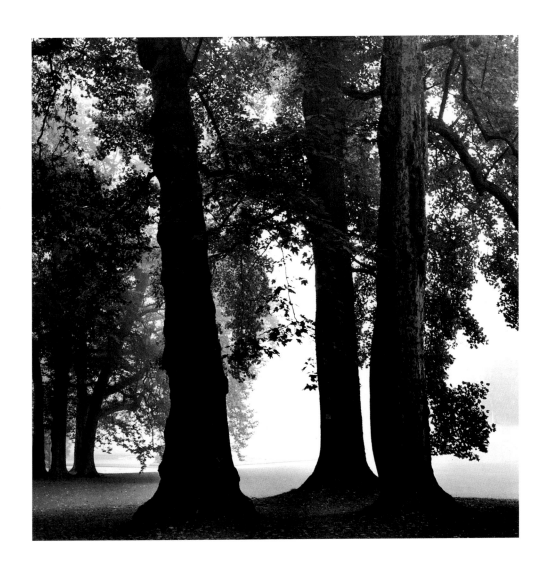

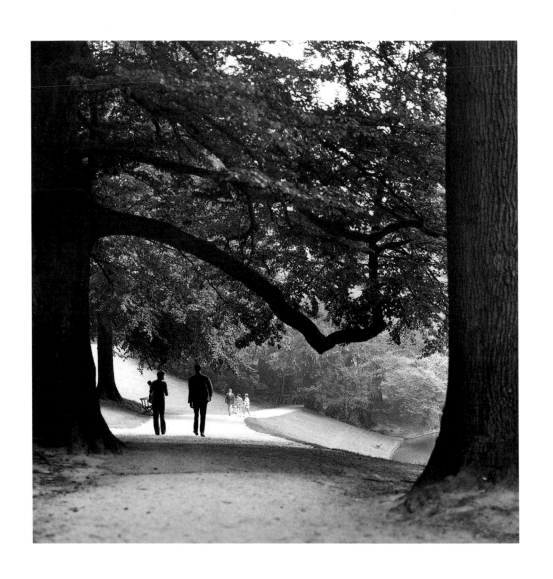

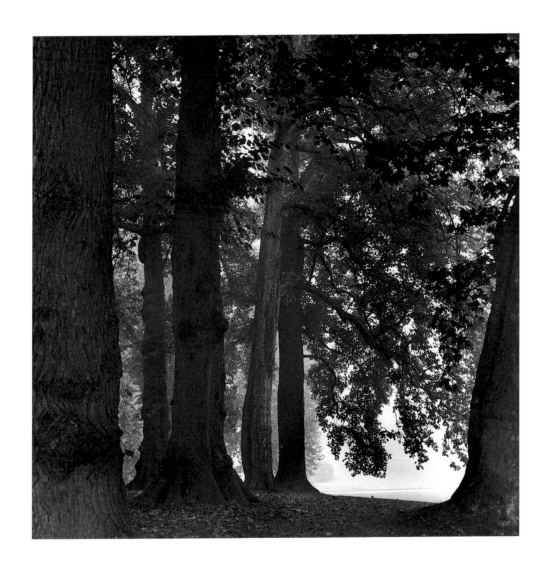

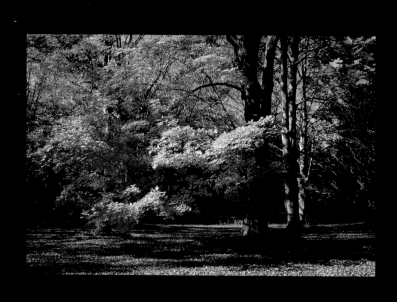

Suspended

Willows along the Saw Mill Parkway Westchester County

New York

Twigs and leaves floating above the ground

without visible support is an illusion. Upon

close inspection we find that nothing is floating.

Each twig and leaf of these willows is connected

to another.

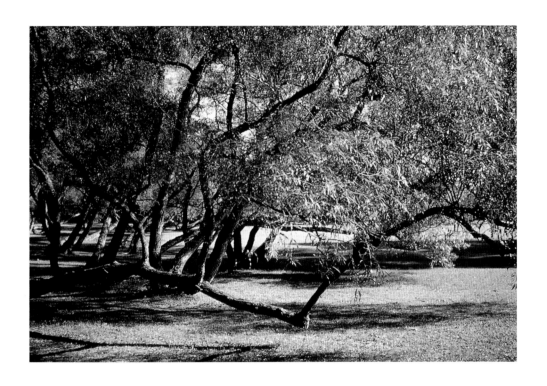

A Flowering Dogwood Branch

Montgomery Pinetum

Cos Cob, Connecticut

A flowering dogwood *(Cornus florida)* branch

floats above the ground. Where is the support?

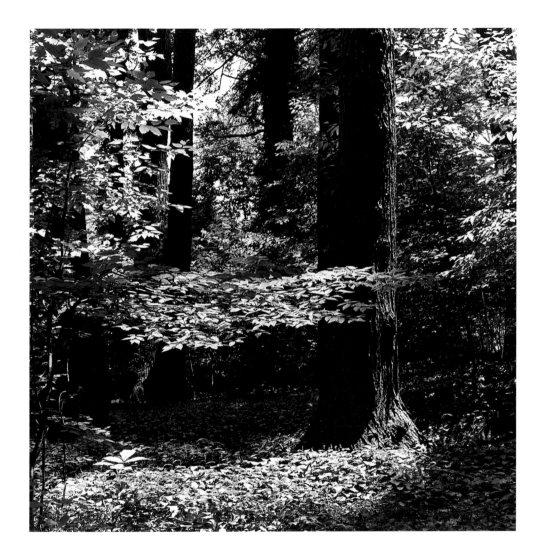

White Pine

Vanderbilt Estate

Hyde Park, New York

The protruding branch of a white pine

(Pinus strobus) looks like a green "cloud"

hovering above the ground.

Spice Bush

Bronx River Parkway

New York

The spice bush *(Lindera benzoin)* looks as if it is

exploding in midair. Its yellow leaves are attached

to the twigs and branches that we cannot see.

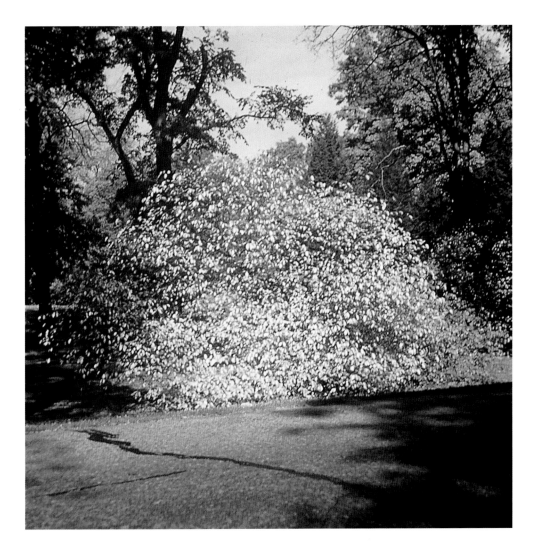

Highbush Blueberry Connecticut Woods

The autumn leaves of the highbush blueberry

(Vaccinium corymbosum) look disconnected from

the branches, hovering in space. The illusion is

revealed in the photograph; the rhododendron

leaves right next to the blueberry bush are in

sharp focus.

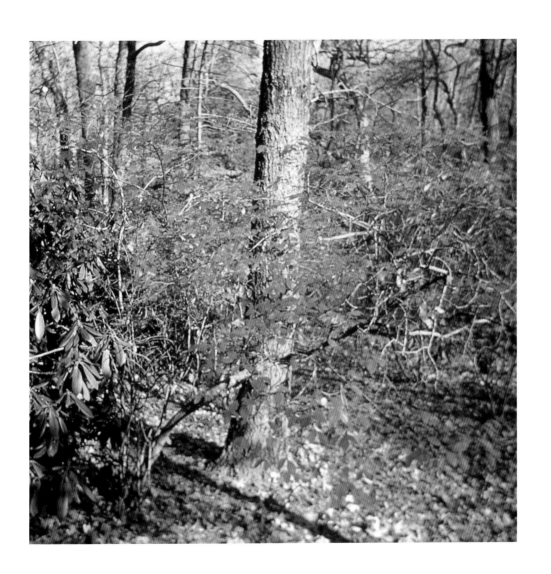

275

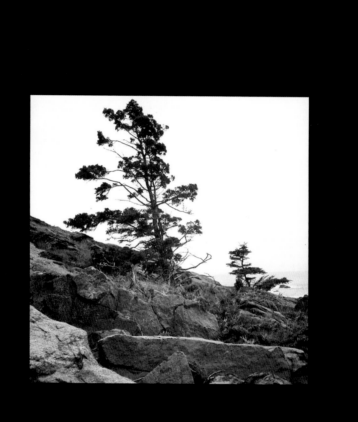

tenacious
Tenacious

Oak Trees

Ridgefield

Connecticut

In a boulder-strewn environment the oaks have

overcome adversity.

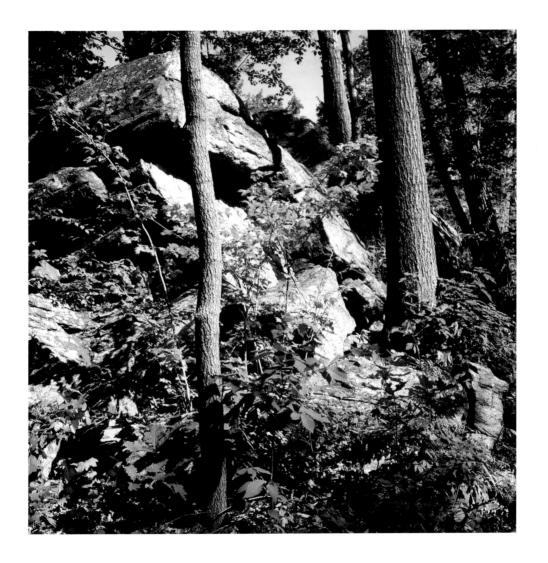

Rocky Countryside

New England

When we see trees growing out of an ancient

outcropping of rock, we infer a certain amount

of tenacity, a will to survive even in the harshest

environment.

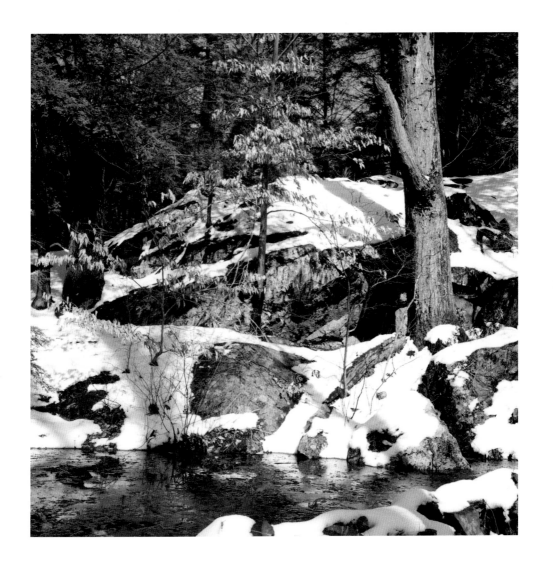

Rock Outcroppings

Oaks and Beech

North Salem

New York

Trees that embed their roots into the crevices

of rock outcroppings and ledges create greater

stability for themselves. This gives the effect of

permanence and a certain timelessness.

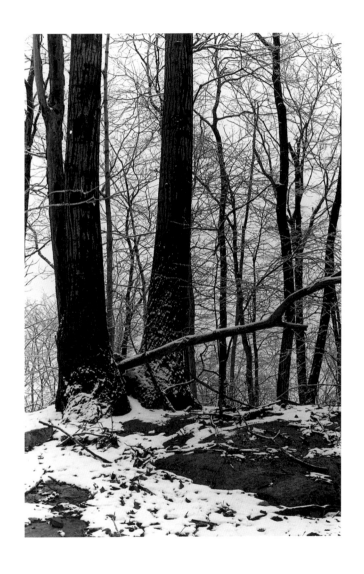

Young Trees Connecticut Woods

The frailty of young trees is enhanced by contrast

with the heavy outcroppings of rock ledge.

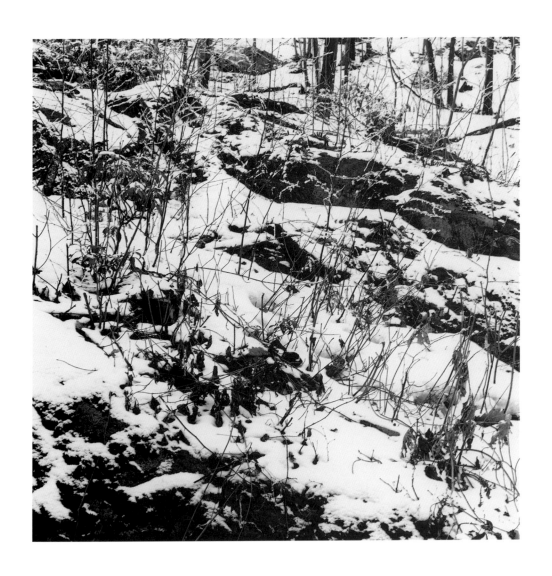

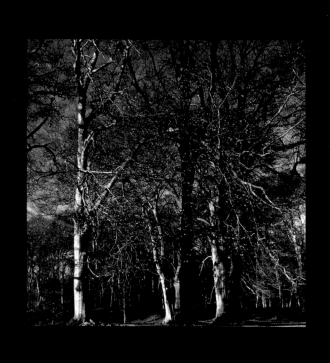

coda Coda 287

People ask, "Is there a unified landscape, either by the hand of man or nature, that you believe shows a pervading mood?" Yes, one in a Dutch Park called Clingendael, a part of The Hague. There we find one kind of tree, the European beech *(Fagus sylvatica)*. They stand with awesome dignity in their old age and great size. They

are broader than tall, and their erratic branching often reaches to the ground—giving them a timeless feeling of shelter. With no other kind of tree competing with them vegetatively, the beeches easily suggest grandeur as the defining mood of the place. They also evidence tenacity, persistence, and fortitude. We see strength in their heavy limbs and adversity in their broken branches and scarred trunks.

They have suffered from the onslaughts of cold, damp wind from the North Sea,

only a few miles away. Yet they have survived, and all their suffering has given

them unmistakable character. If we analyze this scene further, we find that those

who planted them years ago did so with clear intelligence. The trees stand far

enough apart so that each one expresses its individuality. No two are identical.

One gets more light, another more moisture, another better soil. We see how

much space a grand tree needs to manifest its individuality, and we see what

happens to a tree in old age. To a botanist, or a park designer, or an ecologist,

Clingendael must be very satisfying.

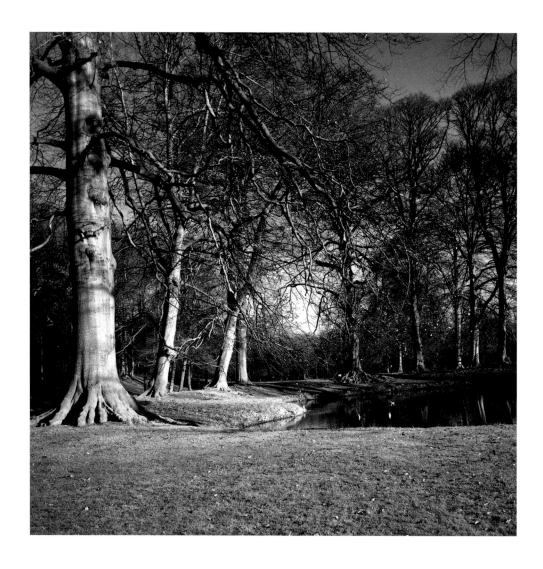

A.E. Bye